MONTPELIER
AND THE
MADISONS

MONTPELIER
AND THE
MADISONS

HOUSE, HOME AND AMERICAN HERITAGE

MATTHEW G. HYLAND

Charleston London

History
PRESS

Published by The History Press
Charleston, SC 29403
www.historypress.net

Front cover images: James Madison, lithograph based on a Gilbert Stuart portrait. *Courtesy of Library of Congress, Prints and Photographs Division, Washington, D.C.;* President Madison's house, Orange County, Virginia, 1836. Prud'homme (after Chapman). *Courtesy of Picture Collection, Library of Virginia, Richmond. Back cover image: Courtesy of the Montpelier Foundation.*

First published 2007

Manufactured in the United Kingdom

ISBN 978.1.59629.277.2

Library of Congress Cataloging-in-Publication Data

Hyland, Matthew G.
Montpelier and the Madisons : house, home, and American heritage / Matthew G. Hyland.
p. cm.
Includes bibliographical references.
ISBN 978-1-59629-277-2 (alk. paper)
1. Montpelier (Va. : Dwelling)--History. 2. Madison, James, 1751-1836--Homes and haunts--Virginia--Orange County. 3. Madison, James, 1751-1836. 4. Madison, James, 1751-1836--Family. 5. Plantation life--Virginia--Orange County--History. 6. Landscape--Virginia--Orange County--History. 7. Architecture, Domestic--Virginia--Orange County--History. 8. Orange County (Va.)--Social life and customs. 9. Presidents--United States--Biography. 10. Orange County (Va.)--Biography. I. Title.
E342.H95 2007
975.5'372--dc22
[B]
 2007019529

Notice: The information in this book is true and complete to the best of our knowledge. It is offered without guarantee on the part of the author or The History Press. The author and The History Press disclaim all liability in connection with the use of this book.

CONTENTS

ACKNOWLEDGEMENTS

In the course of writing this book, many people, too many to name individually, have helped me along the way. Collectively seems to be the best way. So, I wish to thank first of all the community of scholarship fostered in the American Studies Program at the College of William and Mary in Williamsburg, Virginia. Likewise, the community of scholars I have found in the Vernacular Architecture Forum has also encouraged me to see this project through to its completion. Lastly, this book is dedicated to my family, especially Paul and Emilia.

INTRODUCTION

I n the strands of the United States of America's popular creation myth, President James Madison plays the frail, bookish and systematic framer of the Constitution. For instance, in Washington Irving's writings, he appears as "but a withered little apple-John," especially in comparison to his vibrant wife Dolley. As a founding father, we mostly know him, if at all, through his writings in the *Federalist Papers* and as Thomas Jefferson's immediate successor to the presidency. As such, he is considered an echo of Jefferson, bearing the mantle of Jeffersonian republicanism, or the Jeffersonian persuasion, and awkwardly guiding the United States through its second war for independence against Great Britain.

As a person, Madison is less well understood—even less so as a builder. Biographies tend to highlight his intellect, his politics and his statesmanship. Yet we might come to know him better if we look at him through his home, his farm and his building projects. At Montpelier, we can see his vibrant, private side. President Madison put much of himself into his house and his home life. His father was a builder, and he himself twice added on to the house his father built. He earned his livelihood from the plantation. His farm became an expression of himself. To move closer to understanding Madison in his historical context, we should follow him in the rhythms of daily life. His attachment to family and land is reflected in his home, as well as the homes of his siblings. Even in the Commonwealth of Virginia's capital at Richmond, we can see Madison's hand, modest though it may be, in public architecture and expressions of emerging national character.

Previous biographies of President Madison highlight his theories of republican democracy, his contribution to shaping the U.S. Constitution and the struggles of his presidential administration. The focus here is on his interests in building and farming and how the two brought him into a closer relationship with his family, James Monroe and Thomas Jefferson. Yet the differences in appearance between Montpelier and Monticello can

be seen as reflections of President Madison's singular tastes. Some authors have portrayed Montpelier as a manifestation of Jeffersonian aesthetics only. However, the changes President Madison made to the house show such a conclusion to be hasty.

An architectural biography such as this can give us an impression of Madison the man and his family, rather than Madison the symbol. To that end, this account of the house and grounds includes expanded categories of historical experience at Montpelier to enrich the narrative by including women, slaves and the landscape itself. Montpelier has a complex architectural history, but this story is about the Madison family pioneering with their slaves on Virginia's tobacco frontier and rising to prominence—along with the young United States. The Madisons' struggle with slaves, tobacco and politics is part of Montpelier's historical landscape. Such a story, reflected in the development of their plantation, shows their private struggles in a Southern plantation landscape and slave society with its personal and political dilemmas. This architectural history seeks to see Montpelier as a multi-storied house.[1]

CHAPTER ONE

Tobacco culture and its promise of profits brought the Madisons to Montpelier. Marriages and growing families prompted expansion of it. During the 1650s, Virginia planters who had become devoted to the production of tobacco sought to acquire the best remaining river lands along the Potomac, James, York and Rappahannock Rivers. By the end of the 1650s, the land most suitable for tobacco production in Virginia, which is to say land close to navigable rivers, had been patented by a handful of planters from the Tidewater squirearchy. Even inland from the rivers, large tracts of land were being granted to proprietors, such as the Northern Neck Proprietary, who profited from the sale and quitrents. By the 1730s, Virginia's tobacco land, which had seemed endless in the planters' prospect, appeared to be running short. What had been apparently abundant was now becoming dear. Furthermore, fresh fields promised larger crops in a stressed tobacco market that had been yielding low prices throughout the 1720s and 1730s.[2]

Through marriage and well-placed connections in Virginia's colonial administration, Montpelier began as a modest house and agricultural complex first called Mount Pleasant on the early eighteenth-century Virginia frontier. For Ambrose Madison, the possibility of moving out of the old fields in the Mattaponi River drainage came through his in-laws when he married Frances Taylor in 1721. His wife was the daughter of James Taylor, a surveyor appointed by Governor Alexander Spotswood. In 1716 and 1721, Taylor surveyed land along the Rapidan River, an upcountry tributary of the Rappahannock River. On the 1716 survey trip, Colonel Taylor was among Governor Spotswood's party of gentlemen explorers, "the Knights of the Golden Horseshoe," who viewed the Shenandoah Valley from the Blue Ridge Mountains and then returned to Williamsburg in 1716. Although largely symbolic, the journey encouraged interest in land speculating opportunities in western land. For Colonel Taylor, the

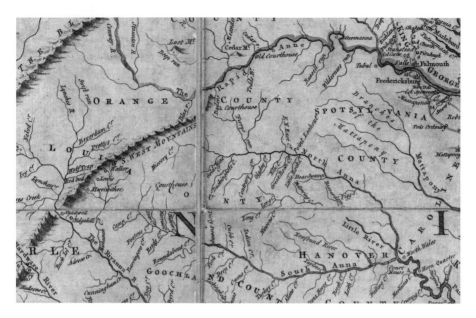

The Mount Pleasant area in the 1750s, detail from Joshua Fry and Peter Jefferson's *Map of the Most Inhabited Part of Virginia Containing the Whole Province of Maryland with Part of Pensilvania, New Jersey and North Carolina*, 1755. London, Thos. Jefferys. *Courtesy of Library of Congress Geography and Maps Division, Washington, D.C.*

opportunity seemed to be for his children, not him. So when his daughters, Frances and Martha, married, he provided them with adjoining tracts in the Southwest Mountains.[3]

In all, the brothers-in-law, Ambrose Madison and Thomas Chew (who had married Martha Taylor), patented 4,675 acres in the western extents of Spotsylvania County. Soon thereafter, the patentees sent an overseer and a gang of slaves upcountry to prove their claim by clearing fields, planting tobacco and meeting other requirements. When the patentees petitioned the Spotsylvania County Court to examine their "Buildings, Workes & Improvements," William Bartlett and Richard Blanton estimated the value of Thomas Chew's improvements at £375, plus a mill at £70. They appraised two quarters of Ambrose Madison on the north side: Todd's Folly Quarter (£40) and "Mount Pleasant [*sic*] Quarter" (£340) and approved the patent in November 1726.[4]

Based on the archaeological record, Montpelier archaeologists have surmised that Mount Pleasant did not deviate from conventional settlement patterns and domestic architecture of the day, with its complex of agricultural and domestic service buildings located near the main house. Common Virginia houses of the day were typically one- or one-and-a-

half-story, earthfast, wood-frame dwellings with two rooms on the ground floor and a chimney on the gable at one or both ends. They may have been covered with unpainted riven clapboards, made by splitting four-foot lengths of the oak timber that was so plentiful in the country. Through extensive archaeological investigations of the Mount Pleasant site, archaeologists have identified kitchen and cellar features in the Mount Pleasant domestic complex and the foundation of the main house. The dimensions and structural system of the main house appear to have been typical of the common Virginia house. Preliminary analysis indicates that the residence stood over a stone-lined cellar measuring eighteen feet by ten feet. Adjacent to the stone-lined cellar, archaeologists identified a root cellar. Based on these investigations, the building most likely was a wood-frame residence measuring thirty-two feet by twenty feet.[5]

The builders may have utilized both a continuous stone foundation and an earthfast foundation system. Also, they may have laid out a two-room floor plan that included a hall and chamber configuration. Current research indicates that part of the main house at Mount Pleasant stood above the adjacent root cellar on hole-set wood blocks—a building method that emerged in the colony during the second half of the seventeenth century— or a timber frame building with hole-set studs, which was predominant throughout the seventeenth century and common into the eighteenth century. Other buildings and structures associated with the plantation may have utilized both construction systems, depending on their function. The presence of stones in the foundation area may be the result of repairing or replacing rotting members of the foundation later in the life of the building. Making repairs, rather than building anew, appears to have been a common practice into the eighteenth century.[6]

In some cases, the interiors of early eighteenth-century residences included a central passage and walls that were lathed and plastered. Documentary and archaeological evidence suggests that the Madisons enjoyed refined interiors, for instance, window curtains and white limed walls. By the time Colonel Madison's father, Ambrose, built Mount Pleasant in the first quarter of the eighteenth century, the house of the Virginia gentry began to feature a central passage and, behind a symmetrical façade, a two-room-deep floor plan. Whereas the common floor plan allowed the hall and the chamber to be entered directly from the outside, the central passage assumed the role of providing access to rooms within the house, allowing the planter to directly and individually control circulation to every room of the house. Furthermore, the central passage channeled movement through the house and buffered the two principal rooms, the hall and the chamber, from unwarranted intrusions on the immediate family. It functioned spatially as

a means of social control. Whether Mount Pleasant reflected the common building form or the emerging floor plan of the gentry, with a central passage, has not been determined.[7]

While most Tidewater planters sent newly purchased African slaves with a white overseer to their new western quarters, the Madisons ventured themselves—a decision with fatal consequences. In 1732, the Madison and Chew families left their familiar neighborhood and community, where Ambrose Madison had achieved local prominence as a magistrate, on the Mattaponi River in Caroline County, having settled their legal affairs. At the time of the move in the spring of 1732, Ambrose's son James was about nine years old, and his two daughters were about seven and six years old. Court records indicate that Ambrose intended to develop the Mount Pleasant quarter immediately; he petitioned the county court for a road to be cleared from "the Dirt Bridge to Fredericksburgh Town in the most convenient way."[8]

While their affairs had been settled in Caroline County, at Mount Pleasant they were not. When they arrived, Ambrose found Mount Pleasant in disorder. Spotsylvania County Court records show that he had suits pending against other men for trespassing and damaging his property. One suit alleged damages totaling six hundred pounds of tobacco.[9] Disorder also extended into the enslaved labor force. Ambrose witnessed the early stages of cultivation for only one crop before his death on or about August 28, 1732. According to Spotsylvania County Court proceedings, three slaves, Pompey, Turk and Dido, were arrested on suspicion of feloniously conspiring in the death of Ambrose Madison.

At their arraignment on September 6, 1732, they all pled not guilty. Two of the slaves, Turk and Dido, belonged to Ambrose. The third, Pompey, belonged to Joseph Hawkins, an officer of the Spotsylvania County Court. At the trial on that same day, "severall Witnesses against them were Sworn and Examined." The officers of the court found Pompey guilty, determined his value to be thirty pounds and ordered him "to be hanged by the Neck until Dead." They compensated Hawkins for his loss of property. By noon the following day, Pompey was dead. As for Turk and Dido, the court found that they were "concerned" in the conspiracy, but not to such a degree that warranted execution. Therefore, the court punished them with twenty-nine lashes each across their back "at the Common whipping post." After the whipping, the sheriff "discharged and conveyed [them] to their said Mistress."[10]

At the time of Ambrose Madison's murder, the tobacco frontier of Piedmont Virginia was a violent environment. For instance, Virginia planters had detected slave conspiracies in 1709, 1710, 1722 and 1726 through 1729.

Changes in Virginia's slave laws (killing a slave during acts of punishment was no longer a felony) and unbalanced slave sex ratios (male majorities) also created tensions. Other disruptions may have led to the murder. These slaves may have just come from a harsh Caribbean plantation or directly from Africa. Or they may have resented such a dislocation from what little community they may have formed at the old plantation. Another motivation for murder may have been changes Ambrose made to the slaves' work pattern or established privileges when he and his family moved into the quarter. Replacing the management of the overseer with his own authority may have provoked the conspirators. Prior to his arrival, the slaves at Mount Pleasant enjoyed a measure of relative autonomy, living beyond the master's direct supervision. Anxious to clear more land, plant more crops and build more structures, Ambrose may have intensified the pace of work. Living among the master and his family meant the end of such autonomy.[11]

Even after the murder of Ambrose, violence and suspicions of slaves continued and remained close at hand to the Madisons. In 1734, the county court ordered Colonel Thomas Chew to build a jail on his plantation. The jail was "a logg house, seven and a half feet pitch, sixteen long and ten wide, of loggs six by eight at least, close laid at top and bottom, with a sufficient plank door, strong hinges and a good lock." Furthermore, years later another white master was killed by a slave in Orange County. That time the county court convicted a female slave named Eve of murdering her master in January 1745, allegedly by serving him poisoned milk. After she spent a few days in the jail on Colonel Chew's plantation, officers of the court burned Eve while she was chained to a rock. In 1747, eight slaves were charged with "conspiring against Christian White People" in Orange County. The court ordered three of them to be whipped and the remaining five released. Even in the late 1760s, violence and resistance to authority were part of life in the community. For instance, a male slave named Tom was sentenced to death for stealing twenty-five cents worth of goods from the storehouse of Erasmus Taylor in September 1767. The judge was Colonel James Madison, Ambrose Madison's son.[12]

The murder of Ambrose also left a glimpse of the household and plantation at Mount Pleasant. An estate inventory shows a well-furnished dwelling and a varied herd of livestock. The inventory of his estate taken after his death reveals a plantation worked by ten adult men, five adult women and fourteen child slaves. This unequal gender ratio (and the large number of child slaves) was typical of the Piedmont's early period of development. The first generation of slaves at Mount Pleasant may have been predominantly African in origin, with a few Virginia-born slaves as part of the group. Tobacco planters in the Madisons' old neighborhood

on the Mattaponi River had been purchasing more slaves during the last five years of the seventeenth century than they had twenty years earlier, particularly slaves from cultural regions within Africa's interior. Previously, slaves had been abducted from the Atlantic littoral regions of Africa. New African slaves composed 90 percent of the slave population and changed the character of life through an infusion of African culture. The Madisons' development of Mount Pleasant with slave labor was part of a wider settlement pattern that eventually brought fifteen thousand Africans into the Piedmont by the time of the American Revolution.[13]

The Mount Pleasant slaves worked to build up the farm and export tobacco. The farm's livestock included a herd of fifty-nine cattle, eighteen hogs, sixteen sows and pigs, nineteen head of sheep and ten horses. Farming utensils included sheep shears, thirteen new weeding hoes, a chopping knife and an iron rake. With no plows or felling axes listed, the slaves were most likely working in small gangs set to grubbing, girdling trees and cultivating the ground between stumps or dying trees with hoes to grow corn and tobacco. When dropping their lambs, the sheep required special care from the slaves. Tobacco plants required constant attention and stoop work, from seedlings in planting beds, to growing plants in the fields, to removing worms, to harvest. Slaves built the casks and hogsheads that contained the stripped, dried and prized tobacco leaves. The inventory lists crosscut saws, handsaws, saw files, an auger, an adz, a hand planer, a cooper's joiner, sixteen thousand 10d nails and twelve hundred 8d nails and "1 Drawing Knife & 1 Carpender Compass." Slaves used these tools to build the hogsheads, barracks and other agricultural structures. Trusted slaves hauled the freight to market.[14]

The Madisons had a large collection of furniture and books. The inventory list includes "1 large Ovill Table, 1 small Ditto, 1 square Ditto, 9 old Leather Chairs, 4 new Ditto, 1 Great Bible, 2 Common prayer books, and 12 other books."

Their goods fit inside a typical Virginia dwelling with two ground-floor rooms and a loft in the story above. Their dwelling was fully appointed with the latest consumer items of the early eighteenth century: window curtains, medicine cabinets, books and a "Swiming [sic] Looking Glass" [a mirror]. They slept off the floor on feather beds with bedsteads. They walked on rugs and kept their clothes in storage trunks. The slave quarters most likely had dirt floors, sashless windows and wooden chimneys. Heaps of straw on the floor served as beds in most cases.[15]

The kitchen held a full array of iron cookware. The inventory lists large pots, pot hooks, pot racks, frying pan, grid iron, spits, tongs, shingles, boxes, vessels and heaters. The inventoried items associated with cooking indicate

a kitchen that lacked little in the way of equipment, including a pair of scales and weights, butter pots and a brass skillet. The presence of iron spits, skillets and an iron box with three heaters suggests that the Madisons enjoyed more than plain fare (stews or boiled dishes). Although they did not have all the kitchen accoutrements suggestive of preparing sophisticated cuisine, some of the inventoried items may have been used for roasting and baking. Frances Madison probably assigned female slaves to work in the kitchen, but that responsibility would not exclude them from being placed in the fields to work. The domestic tasks assigned to female slaves included spinning, cooking, pounding corn with mortar and pestle, washing and candle-making. However, they would also find themselves performing the least desirable chores: building fences, grubbing swamps, weeding, breaking up rough ground with hoes, cleaning stables, spreading manure and tending livestock.[16]

The Madisons' personal objects in the inventory testify to a household that favored the use of material culture specialized for the individual. The inventory documented twenty-three drinking vessels (six cups and saucers, five stoneware cups, eight stoneware mugs and two wine glasses), enough for individuals to have their own. There were enough mattresses for each person to have his or her own. They ate off of pewter plates and imported stoneware for table service and used stoneware pieces for serving tea, more than likely a white salt-glazed English stoneware that had recently come on the market. There were nineteen chairs (nine old leather chairs, four new leather chairs and six flag-bottom chairs), enough for visitors to rest comfortably when visiting. Nevertheless, the rooms of their home still served multiple functions: sleeping, eating, entertaining and working. They enjoyed an elevated standard of sufficiency and comfort that was not the equivalent of luxury, but it was above the material life of the slaves who used broken or wornout items cast off from the master's household. On other plantations slaves acquired some European goods through recycling, theft, barter, purchase and as gifts.[17]

The inventory provides a snapshot of a household engaged in the consumer revolution and plantation slavery. One pair of window curtains, hat boxes, writing paper, candlesticks, new men's shoes, a razor and case, one "Barbor's cason," four horn combs, three new girtles and two pairs of money seals and weights indicate a proclivity toward neat appearances, commerce and home comforts for the Madison family.[18] At the time of the murder, the Madisons appeared to be modeling the lifestyle changes and rising standards of consumption for colonial Virginians at this time. The Madisons of 1733 appear to be well within the consumer revolution's expanding sphere of influence and the trend toward gentility. Their location

in the western reaches of Piedmont Virginia may have prevented their acquisition of some items that residents near or in more vibrant trading centers more easily purchased.[19] The Madisons can be seen as walking among the ambitious planters, land owners and office holders who stood beneath the ranks of the colonial elite and yet above the common farmer and laborer. This middling class had begun to adopt amenities that allowed them to distinguish themselves apart from the ordinary colonist as well as to strike a more enjoyable attitude in life. The pattern of their accumulation of goods that served needs beyond the basics of daily subsistence revealed the Madisons to be a family intent on acquiring the amenities of the day and appreciative of the new style of life.

After Ambrose's death, Frances assumed management of this plantation household with assistance from her brother-in-law Thomas Chew and other relatives nearby.[20] Apparently the prospects for profit in tobacco outweighed any notion of returning back to her old community. She got down to business right away. For instance, she appeared in Spotsylvania County Court in the February following her husband's murder to prove his will. From the court, she received Letters of Probate at that time.[21] She reappeared at the Spotsylvania Courthouse in June 1734 regarding a trespass case John Lathan had filed against her as executrix of Ambrose Madison's estate. The case had been decided in favor of the plaintiff earlier. Yet she had appealed that decision, and in June she learned her appeal was successful. The court reversed itself and ordered the dismissal of the suit and payment by Lathan to Frances Madison for court costs and attorney's fees.[22] Her successful defense against the charge contrasted to her husband's earlier suits as a plaintiff, which were dismissed. Her management of the farm contrasts to the typical impression of eighteenth-century gender roles and cannot be dismissed.

CHAPTER TWO

Soon after the murder of Ambrose, Mount Pleasant came under the jurisdiction of a new county court as Orange County was formed in 1734. Along with her legal activities at court, Frances also acted as a guardian of her son's interests until he reached his majority. Not content to demur to the patriarchy, she prompted Thomas Chew to officially divide the joint patent and deed a moiety to the Madisons in 1737.[23] Frances Taylor Madison witnessed the changes that brought Mount Pleasant out of a frontier tobacco farm into Montpelier, a noteworthy plantation of a locally prominent and prosperous family.

Only fragments of the historical record indicate early landscape changes at Mount Pleasant, but they do show that Frances Taylor Madison continued to shape this landscape. Picking up where her husband had started, she reorganized the surroundings in the same utilitarian manner initiated by Ambrose. For example, she laid out roadways more convenient to her and the plantation's tobacco crop. After petitioning the Orange County Court, they granted her permission to make such a road in 1739. They ordered that "a road be cleared round the plantation of Mrs. ffranciss Maddisson according as laid off by the viewers."[24] Her landscape modifications were guided by commercial ambitions and easier access to markets. Without finding a new husband, she directed the farming operation, overseeing the clearing of new fields and routine tobacco and other agricultural tasks. Aside from managing the field crops, she also maintained a kitchen garden, a necessary household feature, indicated by the presence of at least "1 pair of Gardin Shers" and "1 Tin Gardin pot" in the inventory of Ambrose Madison. As for the tobacco crop, she brought her plantation's tobacco to market under her own brand and managed the tobacco operation until her son James took over the plantation when he was old enough. That Frances Madison took up the business of tobacco stands in contrast to conventional portrayals in Southern history of tobacco culture, that being plantation

leadership squarely as the domain of men and mastery of tobacco cultivation as the pursuit and art of gentlemen.[25] That Frances Madison was skilled in the culture of tobacco can be seen later in the competence of her son James (and grandson James) as tobacco planters in their own right.

Through a family tragedy, Frances Taylor Madison became the mistress of an upcountry Piedmont Virginia plantation. With an overseer and numerous slaves, her tobacco made its way to British markets via Fredericksburg. With assistance from her brother, James Taylor, who had access to local tobacco rolling roads and warehouses in Tidewater Virginia, her farm prospered. Her business practices followed the patterns her husband had established, exploiting the tributary rivers of the Chesapeake Bay to reach across the Atlantic Ocean.[26] In the ships returning from Great Britain, she received all manner of cloth and household goods, as well as books—religious tracts mainly, but also a few texts on medical treatments for sick bodies.

The activities of the Madisons were part of the wider agricultural colonization process at work in the colony, transforming nature as it existed, seemingly abandoned by native groups, into a commodity form. The first step was occupation of the territory and displacement of original inhabitants, followed by the establishment of staple production. The Madisons' arrival first along the banks of the York River and its tributaries, then Caroline County and finally the western extents of Spotsylvania County followed the collapse of Powhatan's chiefdom and the withdrawal of native groups along the Rappahannock River. Eventually, the Madisons seated themselves at Mount Pleasant along a tributary of the Rappahannock River, the Rapidan River and one of its tributaries—Blue Run. Here, what had been the territory of the Mannahoacs, an Iroquoian-speaking native group, became old Indian fields and new tobacco ground in Orange County. Although the Indians may have seemed to the Madisons and other new planters in Orange County to have vanished conveniently into the wilderness, they were remembered. For instance, Thomas Jefferson recalled that the Stegarakies and the Ontponies, two smaller tribal bands of the Mannahoacs, inhabited Orange County. Soon after the dispersal of Mannahoacs, colonizers created transportation and communication systems to integrate the terrain of old Indian fields into the domain of the metropole, and from there to other markets. Thus, economic pressures and imperatives of far-off European markets transformed what was *terra incognita* to Europeans into colonized dominion, resulting in a cultural landscape of growing complexity and a colonizer's perspective and landscape aesthetic shaped by market opportunities. In their clothes, house and grounds, the Madisons modeled such an ideology and contributed to the formation of a dynamic, colonial landscape based on an altered environment.[27]

As the county offices of Virginia colonial administration extended westward from the Tidewater region, local elites within these new jurisdictions found opportunities to climb the administrative hierarchies, from collecting taxes to sitting in court as a judge. Similarly, Frances's son James, like his father before him, filled a variety of offices of public trust in Orange County. James Madison first appeared in the court's book of orders and minutes in 1748, when he was about twenty-five years old and still single. At a county court session on March 22, 1749, the year of his marriage to Nelly Conway (daughter of Francis Conway), the justices appointed him overseer of a nearby road and mandated that he keep it in good repair through the labor of his slaves. He moved up the hierarchy; from 1751 through 1773, he served as a sheriff. In 1753, the county court appointed him to take a list of tithables for the county levy, and he was collecting taxes and counting heads again in 1755, 1766, 1771 and 1773. Sworn in again as a justice of the peace in 1752, he continued to serve in this position intermittently until 1769. In addition to those duties, he was sworn in as a coroner in 1763, and he submitted accounts of that office to the court in 1767 and 1772. He attained the offices of a county lieutenant in the militia while he was still serving as a justice in 1767. He still held this office during the Revolutionary War, although he was anxious to abandon it. His son James advised him to remain in office during the crisis: "Although I well know how inconvenient and disagreeable it is to you to continue to act as Lieutenant of the County I can not help informing you that a resignation at this juncture is here [Williamsburg] supposed to have a very unfriendly aspect on the execution of the Draught and consequently to betray at least a want of patriotism and perseverance." Colonel Madison ultimately passed on the burden of this office later that year, yet he retained the title. His final act of service to the county courts came in 1796, when he was sworn as an acting magistrate, presumably due to a vacancy on the bench caused by the death of his son, Ambrose Madison, who had been serving as a magistrate in 1792 but died in 1794. The county court acknowledged Colonel Madison as a man of standing. From 1753 onward, most Orange County court records refer to Colonel Madison as a gentleman. In addition to his secular offices, he held an ecclesiastical position in the local parish of the Church of England: vestry man. But we're getting ahead of ourselves here. These achievements were by no means inevitable. Rather, they attended to his success as a planter that came gradually.[28]

As Colonel Madison moved upward through county court offices, he expanded his plantation operation. Before his first county court investiture, he constructed a copper still on his plantation in 1747, adding brandy sales to his plantation's output. The still added value to the peaches he

Cartouche detail showing tobacco shipments, from Joshua Fry and Peter Jefferson's *Map of the Most Inhabited Part of Virginia Containing the Whole Province of Maryland with Part of Pensilvania, New Jersey and North Carolina*, 1755. London, Thos. Jefferys. *Courtesy of Library of Congress Geography and Maps Division, Washington, D.C.*

had planted in an orchard. In other sections of his plantation, he made more substantial alterations of the landscape. Plantation records indicate that Colonel Madison had been producing corn and tobacco on his own account and rolling the harvests to warehouses in Fredericksburg from 1745 to 1757.[29]

As a town, Fredericksburg slowly developed along with the region's agricultural trade. London merchant houses specializing in sweet-scented tobacco predominated in the region between the James and Rappahannock River drainages. The Madisons, however, traded with a Liverpool merchant. In Fredericksburg, at Royston's and Crutchfield's warehouses, some of their tobacco was sold to Virginia agents, and the remainder shipped overseas to merchants in Liverpool. There they traded with Thomas and John Backhouse, who provided the Madisons with a variety of goods. The contents of their shipments ranged from the everyday to the ecclesiastical, with some of the items intended for trade with their neighbors. A 1744 invoice describes an order of goods sent to Mount Pleasant that included "1 pr. Mens Shoes, 4 Large Money Purs, 2 Small Do, 1 Groce fish hooks, 20 [pounds] Gun Powder, 500 Needles, 1 Groce Pockett Botls, 80 [pounds] Shot of Lead, 1 [pound] Sewing Silk, 12 Knotts fidle Strings, 2 Dozn. Wash Balls."[30]

Four years later, Colonel Madison managed the account and made payments on behalf of his mother to the Backhouses in Liverpool. With Backhouse-supplied goods, the Madisons established a network of local exchange in the neighborhood. Colonel Madison sold for cash or exchanged for services a variety of items in addition to the ones previously listed: "potting potts, silk, quart and pint muggs, lead, box iron, shoe tacks, shoes, powder and shot, pistols, a rifled gun, gun flints, milk pans, plates, pitchers, cards, cups, earthenware, knives, razors, awl blades, fiddle strings, a violin, an ivory comb, paper, bacon, ginger, pepper, brandy, sugar, wool, cotton, Irish linen, oznaburg, and leather."[31]

Typically, these accounts were settled by way of cash payments and exchanges of corn, tobacco, services and slave labor. In this manner, Colonel Madison participated in and gained wealth from global tobacco markets, British exports and local exchange networks. We ought to recognize that the main house at Mount Pleasant was the focal point of Madison's network of local exchange. The business of sales and bartering brought various people onto the grounds and into the house. For James Madison's mother and his sisters, Elizabeth and Frances, the growing income may have been welcome, but perhaps not the diminishing privacy. The house that may have stood at Mount Pleasant, being the Madisons' frontier home, might not have been large enough and adequately buffered with an ample central passage for both public commercial relations and private family activities. Furthermore, marriage might have strained the living arrangements even more than they already were.

Changes to the landscape continued with the addition of another active quarter of the plantation prior to the French and Indian War. Colonel Madison contracted with Joseph Eve to build barracks for the quarter. Records show Eve began by sawing 288 feet of plank and building a 40-foot house in 1748. The next year, Colonel Madison engaged him again for carpentry while cultivating tobacco there: making two panel doors, mending door sills, raising 94 pounds of tobacco. Eve received brandy, wool, salt and one Testament for his labor. One way to account for this increased building activity would be to recognize Madison's marriage to Nelly Conway on September 13, 1749. Their marriage also explains why, in 1750, his carpentry work increased dramatically—building two 40-foot tobacco houses, two 16-foot-square quarters, four cabins and a 16- by 12-foot corn house for the Black Level quarter. Joseph Eve's account with Madison for 1751 indicates more construction (a 16- by 12-foot corn house, an 8-foot-square dairy and moving a dairy), but it does not specify the location of the work. The next year, all of his work was detailed to Black Level: a 40-foot house, a 16-square-foot quarter, four cabins and mending a

chimney. From 1753 to 1756, during the years when hostility associated with the French and Indian War still existed in the region, Eve's labor covered his rent of a small Madison plantation known as Eve's Lease as well as other items procured through Colonel Madison: shoes, more brandy, 1,150 pounds of pork, 3 pounds of iron and loans of cash.[32] Thus, Madison's labor force consisted not just of slaves, but also tenants.

Colonel Madison acquired more real estate on the eastern slope of the Southwest Mountains from Major Edward Spencer and his uncle, Thomas Chew. He received the books of his mother's library. He had the Crittendens do carpentry and coopering work for him. In 1751, William Crittenden fixed up a house bell, made a cradle (presumably for the newborn baby James), put locks on two doors and mended four chairs. The house bell allowed Colonel Madison to call the slaves to their tasks in the fields and order the workday from his house. The following year, John Crittenden made a safe, repaired six chairs, sawed 116 feet of wooden plank and worked on some wheels: "Getting Spokes for 2 pr. Wheels & Fellows."[33] The Crittendens farmed in the neighborhood while they worked for Colonel Madison. For instance, John Crittenden appeared from 1759 to 1782 in the account ledger of the Reverend Henry Fry in Albemarle County. His account with Fry does not reveal more carpentry work. Rather, it shows John Crittenden paying Fry for provisions and alcohol in kind by bushels of rye, corn and even in cash. It also includes payments of cash made by Fry to Crittenden's son William and two daughters.[34] With Eve and the Crittendens, Colonel Madison relied on the labor not just of slaves but also other white farmers and builders in the neighborhood to improve and expand his plantation.

In the spring of 1752, Colonel Madison expanded his plantation operation on the eastern slope of the Southwest Mountains. He purchased two tracts of 350 and 100 acres, formerly part of the Taylor land granted to his father and Thomas Chew in 1723. He rebuilt his uncle Thomas Chew's derelict mill on the eastern slope of the mountains. The mill provided another opportunity to exploit the labor potential of his slaves. By adding tasks, he added profits. He petitioned the county court in November to allow him to dam Chew's Mill Run. Once the mill began operating, he found it necessary to alter the alignment of a road that passed near the mill so that it would cross his mill run farther upstream.[35] The mill brought prestige and profits to Mount Pleasant, making it a prominent node of exchange and commerce in the neighborhood.

In 1756, Colonel Madison sought to change the layout of another road that passed by his mill, requesting that "the road to be turned from Slaughter's Path the most convenient way up to his mill and from thence to the plantation that was Spencers." Spencer had owned that 350-acre

plantation only since 1751, having purchased it that year from Thomas Chew. Orange County court records document his persistent manipulation of landscape features and the flow of local traffic up until the last years of his life. For instance, the court granted his petition to put up gates on the road that ran from Cave's Ford to his mill in 1790.[36]

Apple and peach trees were also part of Colonel Madison's landscape alterations. Taking advantage of a debt owed to him by Richard Todd, Colonel Madison secured a lease of 100 acres of Todd's private woodland on favorable terms in 1754. Todd, a gentleman from King and Queen County, acknowledged a £200 debt as the first consideration for entering into a thirty-one-year lease of land with Colonel Madison. Thus, for £35 and certain conditions, the first being that Colonel Madison plant the trees, he secured the use of a large orchard containing no fewer than two hundred peach and one hundred apple trees. As part of the deed he pledged to prevent the trees "from being destroyed by creatures." He was allowed to take only timbers to be used for fencing. Approximately ten years later, Colonel Madison secured another lease of land on terms favorable to him. For five shillings and paying "the yearly rent of one ear of Indian corn at the Feast of Saint Michael the Arch Angel only if the same be demanded" by Reuben Roach, he leased 150 acres of land in 1762 that his father had sold to Reuben's father, David Roach.[37]

Colonel Madison's acquisition of land and profits was not limited to small tracts. As he was putting together a plantation of tobacco and grain fields, orchards, stills and mills, he engaged in patenting large, uncultivated lands in Orange County. He secured title to one thousand acres in 1753 and then gave it to his brother-in-law, Francis Conway, of Caroline County, an act of munificence indicative of his growing wealth and his maintenance of relations with family back in Caroline County in the eastern part of the colony.[38] He continued to accumulate more land, all the while adding more slaves to his stock of forced labor. Even without owning slaves himself outright, he benefited from their labor. For instance, he profited from the efforts of his wife's slaves at the Caroline County plantation of his father-in-law, Francis Conway.[39] As he built his new mansion, he dealt away some of his real property holdings west of Orange County.

The appearance of Colonel Madison's brick mansion on the Orange County landscape coincides with marriage and a transition in colonial Virginia house building, from impermanent to more stable architecture.[40] The shift occurred when planters, only those who were able to, moved away from an exclusive reliance on tobacco production to a diversification of cash crops through mixed farming. Cultivating grains (corn and wheat mainly) to exploit new market opportunities proved lucrative, and their

prosperity was reflected in their buildings. Yet the shift to higher-quality housing was limited to the upper classes of society.[41] The Madisons typified this transition in their house, their goods and their aspirations. In this way, they wrote their lives into the new house.

Still a focus of commerce and agriculture, Montpelier was shaped so that it could play a social role in its surroundings. The brick mansion fit into the emerging high-style, regional form of building that combined ideals of Georgian British style with local conditions and workmanship. It was a style of housing neither taken directly from the pages of a pattern book nor tightly bound to regional imperatives. Service as a vestryman in the local Anglican parish that built a new church provided Colonel Madison with exposure to the latest building forms.[42] The house became his architectural statement attesting to his rank in Orange County society as well as an elegant environment for new domestic concerns and appetites. By building a new house, Colonel Madison resolved the spatial dilemmas and incongruities of their modestly elegant, prosperous and commercial life among slaves in his deceased father's dwelling—a dwelling that served as an expedient response to the world of frontier tobacco production and slavery in eighteenth-century Virginia.

Moving their residence also signified a new arrangement in the landscape shared by the Montpelier slaves and their master. At the new house site, a brick wall was constructed on both the north and south sides of the building. A fence followed along the roadway before the house. The brick walls, which were identified through archaeological investigations, marked the division between work areas and formal space around the house. The brick walls separated the house from the blacksmith shop and slaves' quarters sited to the north and slaves' quarters to the south. The Madisons' home lot was more clearly delineated than it had been at Mount Pleasant—showing how they had changed the arrangement of their lives among slaves.

The massing of Montpelier followed the typical house of tidewater Virginia gentry. Prior to its later additions, architectural historians have surmised that it stood as a Georgian-plan, two-story, five-bay-wide, two-room-deep, symmetrical building built of brick laid up in Flemish bond. On the first floor, the house featured a wide central passage between front and rear doorways. The passage offered access to other first-floor rooms. The stairs were located in a rearward chamber off the central passage. Montpelier's passage functioned more efficiently than the passage may have at Mount Pleasant. At Montpelier, the central passage was circulating people through the house while buffering the family from the household's public realm. Subsurface investigations have revealed that the Madisons finished a portion of the walls in their passage with wainscoting.[43] This type

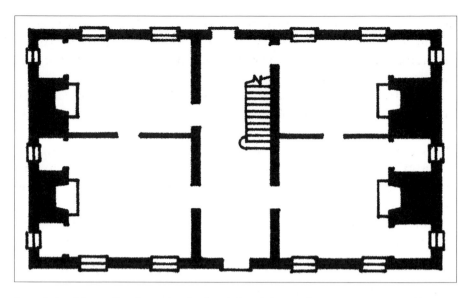

Speculative Montpelier floor plan in the 1760s. *Courtesy of Historic American Buildings Survey, Library of Congress, Prints and Photographs Division, Washington, D.C.*

of wall treatment suggests that the Madisons had raised the level of finish here because the space was doing more than circulating people through the house. Compared to the arrangement of the typical Virginia house's floor plan, the function of central passages at mid-century was changing from an instrument of social control to a viable social space and icon of status—taking on a new social significance.[44]

The best rooms of the house, the dining room and the parlor (also called the hall), were invested with social functions that were signaled by a higher level of decorative finish. The Madisons called their parlor "the hall." We know this from accounts showing that William Lumsden plastered the hall, the porch and the hall closet in May 1791.[45] Typically, planters gave their parlors a higher level of finish and ornamentation since they functioned as the principal entertaining room.[46] As seen in the Madisons' new house, as well as other Virginia plantation houses, the parlor/hall was the core of the planter's ordered world. At Mount Pleasant it may have been a general purpose, living and working space, but by the time of Montpelier's construction, parlors, especially in plantations in Virginia's backcountry and upper Piedmont, had become the setting for manifestations of a household's hospitality.[47]

On the same side of the passage as the hall was the aforementioned closet, or back room of the parlor/hall, a narrow space with a social role that was not clearly defined. It may have functioned as storage space. The remains

of a small fireplace, however, suggest that the room was used for more than storage. Planters often set aside such interstitial spaces as expedient sleeping areas for their slaves.[48] For example, a former Virginia slave recalled that his family lived in a two-story building that was a kitchen primarily. According to that recollection, the first floor included the kitchen and a second room, and the second floor was for sleeping. "Mammy en pappy en de other chillun sleep in dat other room, en in de kitchen too. Upstair yo could stand up in de middle en on de sides yo can't, kaze de roof cuts de sides offen, but part er de chillun stay up dare."[49]

Most planters positioned dining rooms in front of the chamber, a space expected to provide more privacy. Dining rooms offered direct communication with the chamber and the parlor, mediating traffic between the public parlor and the more intimate chamber. Offering another opportunity for the display of refined goods and behavior, dining rooms functioned as a secondary front room with the chamber as a back room. The dining room relieved the hall of its traditional role in food preparation and allowed it to flourish as an entertaining space with a public character. A detached kitchen stood nearby on this, the south, side of the house.[50]

While the downstairs combined private domestic concerns with public and social needs in the hall and opportunities for conspicuous refined display in the dining room, the upstairs was meant to be private. With twelve children born to the Madison family between 1751 and 1774 (only seven lived to adulthood), the degree of privacy available upstairs was limited. The enclosed staircase offered access to the second floor from the central passage. The staircase rose into a central room surrounded by four chambers on the second floor. Three of the four rooms were heated by fireplaces.[51]

These interior spaces complemented an increasing attention the Madisons paid to their personal refinement. For instance, correspondence with a British purveyor of fine clothing, including hats, demonstrates Colonel Madison's striving toward refinement. After an older hat had worn out, he attempted to replace it with one of equal style, but the new hat did not meet his discerning tastes. So he complained about the cost and the look to Clay and Midgely: "I think you was imposed on in the Price of the White Hatt you sent me. It is not so fine as one you sent me at 15/. [shillings] in the Year 1766."[52]

Not just a well-dressed man, Colonel Madison was also well armed— with a fine English rifle, which the Orange County militia impressed for duty in the Revolution. The books he and his mother acquired attest to their elevated status as well. In 1794, he prevailed upon his son, James, in Philadelphia to look into buying a pianoforte for his daughter.[53]

His goods and his house were just two of many facets in Madison's material world. Camille Wells's account of the planter's prospect from descriptions in

real estate advertisements provides a fuller understanding of what Colonel Madison may have been up to with his organization of the Montpelier landscape. Colonel Madison's changes coincided with efforts other Virginia planters made toward improvements of the countryside in eighteenth-century Virginia. While the house stood as an example of conspicuous construction, other material features of the Montpelier landscape signaled purposeful and attentive farming activity. The still in the still house (that may have operated on a seasonal basis), the tobacco houses, granaries, crowded slave quarters, ditched fields, irrigated meadows, dams, mill races, cleared roads, a dairy, a meat-house and sturdy fences—all articulated Colonel Madison's goal toward order and control.[54] The field crops of wheat, rye and tobacco were supervised by men hired as overseers. A former overseer, Thomas Melton, recalled Colonel Madison's ordered world in his description of harvests of corn, "fine crops" of wheat, tobacco and hay. As for livestock, Melton declared Colonel Madison kept "on hand a large stock of cattle, but they were very sorry," all manner of swine, horses and a large herd of sheep, but due to previous sales, "they were indifferent."[55] In cleared fields, sheep roamed with cropped ears duly recorded in ledgers. An account with Thomas Bell showed that Colonel Madison credited him for making a loom to support the plantation's self-sufficiency during downward cycles in the tobacco market and to diversify his sources of income.[56]

The Montpelier plantation was not Colonel Madison's only source of profit. He collected rent on Oaky Mountain plantation in Culpeper County by leasing it to Richard Taylor in 1776 and 1777. Nicholas Porter Jr. rented the same plantation at Oaky Mountain, which Colonel Madison described as "my Plantation in Culpeper at the German Ford," from 1780 through 1783. Madison's tenants also made improvements to his estate. In 1783, he credited Porter for "sundry improvements on the Plantation you rented of me." Madison rented out an unspecified plantation to Moses Joseph in 1779 and 1780 for wagonloads of coal in return. Colonel Madison also rented out a portion of Black Level to William Acry in 1783.[57]

His account books documented the transportation networks he used to bring his farm produce to market and market goods back to his farm. He brought bar iron to Montpelier from Fredericksburg by wagon, sometimes leaving the shipments at a neighboring plantation to be retrieved by Sawney, a slave. However, he entrusted the bulk of his shipping to white men. For instance, his account with Captain Benjamin Johnson showed that he shipped four hogsheads of tobacco to Philadelphia on Johnson's wagon in 1776. On the return journey, Johnson hauled back "a Tun of Iron from Marlbro Forge." Later that same year, Johnson hauled two hogsheads of tobacco to Fredericksburg for Colonel Madison. William Sobree cleared

his debt to Colonel Madison by "waggoning Box of Books & 400# Bar Iron from Fredericksburg." In 1780, Colonel Madison sent his wagon, accompanied by Samuel French, to Richmond.[58] Butler Bradburn hauled two hogsheads of tobacco to, and fifteen bushels of salt from, Richmond in 1780. The following year he hauled 404 pounds of sugar and coffee back from Philadelphia. Bradburn made more trips to Fredericksburg and Richmond tobacco warehouses for Colonel Madison in 1782 and 1783.[59] Colonel Madison maintained his commercial ties to Fredericksburg as late as 1799 by paying Thomas Turner to haul sundries and iron from there.[60]

The enslaved smiths at Colonel Madison's smith shop used that German and Swedish iron brought from Philadelphia or Fredericksburg for farrier work, nail production and tool manufacture. By reworking these imported iron resources, the slave smiths created finished pieces and useful implements for the farm and for sale. Archaeological investigation of the area revealed numerous metal fragments, gun parts, bar iron, slag and knife blades.[61] The slaves hammered out all manner of agricultural implements. They shaped and fitted out plows and colters, axes, hatchets, knives, scythes and hoes. They shoed horses and repaired wagons.[62] Slave smiths usually made the iron hoops used for binding the tobacco hogsheads.[63]

Slaves attended to other activities that were crucial to blacksmithing. Field hands felled trees that would be cut and carefully burned into charcoal. Heat from the burning charcoal in the forge rendered the iron malleable. At Montpelier, forging was done by slaves. The enslaved smiths hammered the iron bars to consolidate the metal, strengthen the strands and expel the slag (impurities). They heated the iron and formed it into the necessary shapes by hammering and bending it on an anvil. They finished the piece by working it with a chisel and file to produce the final, marketable form. In this way, they manufactured musket locks, nails, metal tools and hardware, among other things.[64] Colonel Madison's slave blacksmiths fabricated a "4 inch Spiral Augor" for Thomas Jefferson in 1777. Colonel Madison relied on his enslaved smith's knowledge in the management of the shop. Writing to John Cowherd, Madison stated, "I have jumpt 2 of your Axes, Moses says another only requires being [upscaled]." Madison also hired out his blacksmith slaves. For instance, James was hired out to Colonel Zachariah Burnley for a few days in 1784.[65]

The skill and service of the Montpelier blacksmiths later earned them special recognition in Colonel Madison's will. He made a special stipulation regarding his blacksmith slave Moses by setting him up for sale to the highest bidder among his heirs: "I desire my Black smith Moses may belong to such of my children as he shall chuse to serve if they are willing to take him at a reasonable price that shall be set on him by three disinterested Men."[66]

One of Madison's former overseers described Colonel Madison's blacksmith shop, where he "kept two fires almost constantly going during working hours & had of course two sets of tools & a large neighborhood custom to his shop."[67]

Some Montpelier slaves worked the nearby fields under Colonel Madison's hired white supervisors. Others worked under Sawney, the previously mentioned Madison slave who freighted bar iron from neighboring plantations back to Montpelier. Sawney appears to have enjoyed a special position on the plantation, having accompanied James Madison Jr. to college in New Jersey and overseen a quarter. The other slaves under the supervision of James Coleman and Thomas Coleman produced tobacco crops in 1782 and 1783. James Coleman had been Madison's overseer since 1776.[68] A few slaves were hired out.[69] For instance, he sent the "Negro Woman Eve" to William Mansfield, and in return Colonel Madison received one hogshead of tobacco already stored at Rockett's warehouse in Richmond. Sawney, who may have served as a tobacco overseer, was responsible for a quarter that bore his name. Colonel Madison noted it in his ledger as "Sawney's Hhd No. 13. his own crop."[70] In January 1835, Thomas Melton, who had worked for six years as a Montpelier overseer, stated, "Colo Madison had four plantations, but one was a very small and unprofitable one, he keeping on it only a few old negroes who did not support themselves. His land was generally much worn but he made as good crops as were generally made in the neighborhood."[71]

Colonel Madison's crops arrived at European markets through a variety of local towns. For instance, the 1782 and 1783 crops were carried to Rockett's warehouse in Richmond and sold to agents of William Anderson & Company of London.[72] In 1787, the Andersons, knowing that Colonel Madison had tobacco at Royston's warehouse in Fredericksburg, again invited Colonel Madison on June 12 to convey his tobacco to their ship waiting at West Point, Virginia. Instead, he shipped his 2,382 pounds of tobacco via Captain John Powell's ship *Active* to the merchants Clay & Parry in London.[73] Colonel Madison also divided his 1782 tobacco crop, paying Thomas Coleman to haul four hogsheads to Fredericksburg and more than one hogshead to Richmond.[74]

Along with slaves he had inherited and acquired through marriage, Colonel Madison added to the slave population of Montpelier through direct purchase. He credited James Coleman's account in 1791 with the value for three slaves Coleman sold him: Joe (£63.15), Peter (£75.0) and Dido (£59.0).[75] According to a list of shoe sizes of his slaves, Colonel Madison held fifty people in slavery in 1787. His 1786 personal property tax return identified seventy-four slaves and two overseers under his name; however,

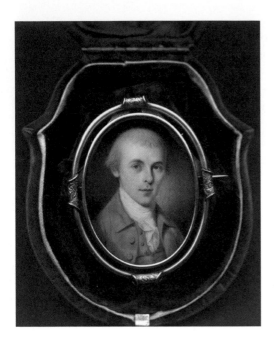

James Madison by Charles Willson Peale, 1783. *Courtesy of Library of Congress, Prints and Photographs Division, Washington, D.C.*

only thirty-nine of the slaves qualified as tithables. There were thirty-four young negroes enumerated, along with sixteen horses and seventy-six cattle that year.[76] Sick or injured slaves were treated on the plantation by James Madison Jr. on at least one occasion. Records show that while his father was in Fredericksburg in March 1777, James Jr. treated one slave's swollen arm by bleeding him. In a letter to his father, James Madison Jr. wrote:

> *The family have been pretty well since you left us except Anthony* [a slave]. *He was taken on Wednesday morning with a strong Ague succeeded by a high fever and accompanied with a pain in his Stomach and side. The Swelling in his Arm also increased very considerably and became hard and painful. I was a good deal at a loss in what manner to proceed with him being unable to form any Judgmt. of the nature of the Tumor or the effect a proper treatment of his other complaints might have on it. I ventured however to have a pretty large quantity of blood taken from him and had his arm kept moist by the usual Poultices, which has answered every purpose I cd. have hoped. His fever and pain have gradually abated and I have no doubt but he will be perfectly recovered from them in a few days, and the Swelling on his arm seems to be subsiding fast.*[77]

Colonel Madison may have been in Fredericksburg in part to attend to his interests in the slave market there. He, along with a partner in

Fredericksburg, brokered slave trades, a business activity that becomes evident in the Madison family's later relation with Sarah Madden and her offspring.

At this time, the Madisons were seen as recent members in the league of Virginia grandees. By comparison, when Robert Carter of Nomini Hall, a member of the leading Virginia slave holding dynasty, arranged to manumit 509 slaves in Westmoreland County in 1791, Colonel Madison owned roughly 100 slaves. John Tayloe of Mount Airy held roughly 700 slaves at about the same time.[78] Beginning in 1782, Orange County tax records documented the value of Madison's land, material goods and slaves. Starting with 84 slaves in 1782, Colonel Madison died in possession of 108 slaves of all ages in 1801. By the time of his death, he was responsible for taxes on 3,029 acres.[79]

During the Revolution, many Virginia plantation slaves ran off to the British with hopes of freedom. Lord Dunmore had offered them their freedom if they fought for the Crown. As for the free blacks in Virginia during the war, James Madison Jr. proposed that the Virginia General Assembly create a regiment of free blacks who wished to enlist. Slaves not serving either army, or seized by either army, oftentimes fled the plantation. For those slaves who stayed at their plantations, work routines changed. Masters set them to home manufactures rather than producing tobacco for export, as the war had destabilized the international tobacco market.[80]

The Madisons recorded the loss of two slaves at this time. One named Anthony, perhaps the slave James treated in 1777, ran away on two occasions. As for the other slave, named Billy, Colonel Madison's son James sold him in Philadelphia after realizing that holding him in slavery would be futile. Billy had accompanied James to Philadelphia and, inspired by ideas of liberty, had made it clear that he would no longer be suitable for the life of a plantation slave. The younger Madison wrote to his father in 1783, "I am persuaded his mind is too thoroughly tainted to be a fit companion for fellow slaves in Virga…I do not expect to get near the worth of him; but cannot think of punishing him by transportation merely for coveting that liberty for which we have paid the price of so much blood, and have proclaimed so often to be the right, & worth pursuit of every human being."[81]

He sold Billy at a time when the general assembly of Virginia had repealed prohibitions against the private manumission of slaves in 1782. Ten years later, however, the general assembly, fearful that free blacks in the commonwealth would undermine the slave system, reimposed restrictions on manumissions. Gabriel's Conspiracy led to further restrictions after 1800.[82]

CHAPTER THREE

Military engagements during the war did not affect Montpelier directly. One of Madison's sons, Ambrose, guarded British and Hessian prisoners of war in Albemarle County and served as a lieutenant and paymaster of the Third Virginia Regiment in 1779.[83] The house did, however, provide a safe haven for some who left their homes closer to the Tidewater battlefields, such as Edmund Pendleton, who fled his Caroline County home in the summer of 1781 when Virginia relied on General Lafayette to defend it against the British invasion.

During the threatening hostility, Pendleton briefly stayed at Montpelier. He wrote to James Jr. to say he had spent "a few happy days at yr fathers, who I was glad to find enjoying fine health." Pendleton praised "the Salubrious Air of his fine Seat, not to be exceeded by any Montpelier in the Universe." He concluded by saying, "I wish you would hasten peace, that you may return to the Influence of it upon your crazy constitution."[84] Produce from the farm also supplied troops. Colonel Madison provided 262 pounds of bacon, 785 pounds of beef and 24 gallons of brandy in 1780.[85]

After the war, some Virginia slave owners found themselves holding a surplus of enslaved laborers. Some planters immigrated to Tennessee and Kentucky to establish new slave plantations there. Colonel Madison had eighty-four slaves at his quarters in 1782, and he faced a similar dilemma. To resolve it, he drew up his will and began breaking up the Montpelier slave community. Changes in the Montpelier slave community paralleled changes in the Madison family, as the Madison children came of age and began their own farming operations. Nevertheless, their father remained a close advisor involved in their development as planters themselves. An early change in the slave community came when Colonel Madison deeded his son Ambrose 350 acres of adjoining land in 1781.[86] Located on the eastern slope of the Southwest Mountains, Ambrose worked this plantation for thirteen years with slaves given to him by his father. Ambrose received

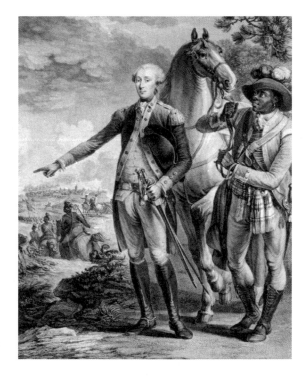

Conclusion de la campagne de 1781 en Virginie. To his excellency General Washington… peint par L. le Paon peintre de Bataille de S.A.S. Mgr. le Prince de Condé ; gravé par Noel le Mire, circa 1785. *Courtesy of Library of Congress, Prints and Photographs Division, Washington, D.C.*

the title to ten slaves in the 1787 will, but he had taken possession of them earlier. By 1787 two slaves had died and one, a daughter of Celia, had been sold by Ambrose.[87]

Another son, Francis, received legal title in 1787 to "the servitude of an Indentured Mulatto Woman named Sarah Maddin and her Children." She and her family had been transferred to his Culpeper County farm, Prospect Hill, in 1782. Before the will had been made out, however, Sarah Madden ran away from Francis's plantation, punctuating the disruption caused by this post-Revolution rearrangement of the Montpelier labor force. In 1783, she ran to Fredericksburg, where she explained to Judge James Mercer that she had fled because she feared Francis was about to sell her into permanent slavery to a man in York County, Pennsylvania.[88]

Sarah's mother, Mary Madden, was a free white indigent living on public charity in Spotsylvania when she bore the child of a slave in 1758. That child, Sarah, was indented as a two-year-old child to a Fredericksburg merchant who, in partnership with Colonel Madison, brokered slave sales in the local market. George Fraser, the merchant, died in debt to Madison in 1765. Madison settled the £400 debt in 1767, in part by taking Sarah, who at nine years old still had twenty-one years left on her indenture, to Montpelier. The Madisons trained her as a seamstress, laundress and domestic servant. By

the time she moved to Francis's farm, she had given birth to three children. While she was away in Fredericksburg, Francis Madison sold the indentures of two of her children. Sarah remained at Prospect Hill for the remainder of her indenture and died in Culpeper County in 1824.[89]

Francis's brother William received three slaves. These two brothers, Francis and William, received divided parts of a large tract of land in Culpeper County that their father had purchased from Benjamin Grymes. Francis received a thousand acres, while William got an unspecified amount—"the remainder of the said land."[90] Later, William enlisted the help of his brother James in building a house at his farm in Culpeper County. Francis and William still relied on their father's management of their farms. For instance, in a letter to his son James, Colonel Madison complained about an accounting error and the status of Francis's tobacco:

> The specimen you sent me from Mr. House of his method of reducing the gross Hundred, I have been acquainted with long since; before either you or he had existence; but the Acct. of Sales he sent did not agree with the rule, which I suppose was from some mistake in the calculations; I believe I gave you his Acct. to have it corrected; He also omitted to enter one of the Hhds. I should be glad of a seperate Acct. of my 30. Hhds Tobo. & of Frankey's [Francis Madison] 2 markt FM. if he can render it: And of some money for it, if you have not made use of it all, for the prospect of my getting any for the Bonds you left with me is not very promising at present.[91]

Colonel Madison gave fifteen slaves to his daughter Nelly when she married Isaac Hite Jr. The slaves relocated with her across the Blue Ridge Mountains to the Hite plantation in Frederick County, Virginia.[92] In addition, Colonel Madison directed that upon his death, his son James would inherit the 1,800 acres that constituted Montpelier and an unnamed 400-acre plantation on the Rapidan River in Culpeper County. James and his brother Ambrose jointly received 219 acres of land in Louisa County.[93] Although some slaves were dispersed from Montpelier after the revolution, the reorganization of the labor force was made largely within the Madison family and within the region.

Some of the Montpelier slaves were set to work on two of James Madison Jr.'s farms. His first farm, Black Level, was carved from the estate of his father in September 1774 and had been farmed on occassion by tenants.[94] Later, he received a 560-acre plantation from his father on August 26, 1784.[95] Soon thereafter, he purchased 800 acres from John and Elizabeth Lee in July 1792.[96] The 560-acre tract was called Sawney's Quarter and

the 800-acre tract was called Black Meadow in the nineteenth century.[97] In September 1793, he purchased from Elizabeth Chew 30 acres that were also part of the Black Level tract.[98] James Madison Jr. also leased part of his land to his brother. A merchant in Fredericksburg wrote, "I have today drawn on you in favor of French L. Gray for £21.0.0 VC at 20 days Sight, it being the amount of sundries furnished Your Brother for the use of your plantation the last year, which you'll please honor and place to my debit."[99]

James Madison Jr.'s first appearance in the Orange County tax records occurred in 1787. At that time, the county assessed him for six blacks above sixteen years of age, eight under sixteen years, four horses and two cattle. In the 1790s, overseers were responsible for his farms. In 1794, his tax assessment included two white tithables, most likely his overseers Lewis and Mordecai Collins, twelve slaves over sixteen years of age, three under sixteen years and fourteen horses. In 1797, he paid taxes on one white tithable, thirteen slaves over sixteen years of age, four under sixteen years, nineteen horses and one coach.[100]

Select correspondence between James Madison Jr. and his father reveals the character of the Madisons as masters over their slaves. On one occasion previously mentioned, a slave became sick, and young James Madison treated him by bleeding him. In his absence, James Madison Jr. left written instructions and relied on his father and brothers to see that they were executed. In the instructions he left for overseers in 1790, he ordered changes to the traditional plowing patterns. In addition, the slaves erected new outbuildings, corn houses and stables and fenced in new fields. Slaves dug ditches and laid up dams to irrigate new meadows. James demanded that the slaves cultivate in a new way: "plowing all round each parcel, instead of the common way by bands." Fields of timothy oats, wheat and rye were planted, and clover germinated in cornfields left fallow. A field of potatoes took over ground previously allotted to tobacco in Sawney's Quarter.[101] Madison described these farms to Thomas Jefferson in 1793:

> *On one of two little farms I own, which I have just surveyed, the crop is not sensibly injured by either the rot or the rust, and will yield 30 or 40 perCt. more than would be a good crop in ordinary years. This farm [Sawney's] is on the Mountain Soil. The other [Black Meadow] is on a vein of Limestone and will be less productive, having suffered a little both from the rot & the rust.*[102]

From Philadelphia in 1794, he planned with his father another orchard of fruit and nut trees:

> *It does not seem necessary to decide now on the spot for the Peccan trees, if any should proceed from the Nuts left with you by Mr. Jefferson. They can be easily removed at any time. I have not fixed on any particular no. of Apple Trees. I would chuse a pretty large orchard if to be had and of the sort you think best. If a sufficient number cannot be got for Black-Meadow & Sawney's, I would be glad to have them divided; & if not worth that, to be planted rather at Sawney's.*

The same letter begged for information regarding the state of his farms. "What is the prospect in the Wheat fields? What account does Collins give of my Timothy? What has Louis Collins done, and what doing?"[103]

The report from his father, aside from the completion of planting apple trees at Sawney's Quarter, disappointed him: the corn crop was deficient, and the "Dams at the Ditches are all broke: they must be done with Stone; when convenient."[104] He sent his father instructions for sowing oats: "M.C. may fence in part of the meadow as he proposes for a pasture…I approve the size of the Granary you have prescribed to L.C. As soon as that jobb is over, he can be making provision for the Stable according to directions formerly given, unless something more urgent interfere. You have never mentioned to me whether Mr. C's mill pond has affected my meadow."[105]

The assessed value per acre of James's farms remained constant through 1797: £7.9. on Sawney's and £14.1. on Black Meadow first in 1793, but it leveled out at £11.1. from 1794 to 1797.[106]

The slaves were sowing wheat and revitalizing old fields with clover. James wrote to his father in November 1794 about preparations for wheat

> *by a vessel which sailed yesterday for Fred. I have sent you…another Barrl. with 1½ bushls. of Red Clover seed, which I wish you to make Sawney sow in Feby. on the old mountain field. There will be eno' for the whole field whether in Wheat or Rye, and he will so distribute it as to make it hold out. It is to be sown on the top of the Wheat or Rye, taking advantage of a snow if there be one particularly just before it melts. But this circumstance is by no means essential, and ought not to retard the sowing beyond the last of that Month.*[107]

Tobacco maintained a presence in the Madisons' fields, even though events in Europe drove up the price of wheat. His merchant in Fredericksburg, Fontaine Maury,[108] notified him about his tobacco sales in 1789 that "I have shiped the remaining three hhds of your Tobacco to my Brother [in Liverpool], and you may draw as usual on them."[109] Madison's interest in tobacco, as well as grains, is documented in a May 1790 letter to his father.

In that letter, he advised his brother to ship or postpone the sale of the tobacco, rather than sell at the prevailing local price. He wrote, "I am more & more convinced that this will be prudent. The price has risen considerably in Europe, and from causes that will be more likely to carry it still higher than let it fall lower." Due to the turmoil caused by the French Revolution, Madison suspected that the price of wheat also would remain favorable in America, and "particularly Virginia will divert labor from others, and from Tobo. among the rest. This alone will prevent a low price, by circumscribing the quantity raised."[110] The Madisons took advantage of Montpelier's elevation and fresh fields in order to grow what James Madison Jr. once called "Mountain quality" tobacco.[111] As a measure of the Madisons' skill in growing tobacco, their merchant in Liverpool, England, noted in 1789 that the tobacco in their hogsheads had been "treated very judiciously."[112]

James used the profits from his tobacco to supply the overseer of Sawney's Quarter—the slave Sawney himself, who had accompanied Madison to school in New Jersey.[113] When Fontaine Maury notified him of shipments of their tobacco from Fredericksburg to Liverpool in July 1790, he also listed items for "Negroe Sawney." He wrote, "I have Shiped to the address of my Brother Six hhds tobacco being the amount of your Crop, should you have occasion you can draw as usual." His account with Maury documented payments for drayage, oznaburgs and rolls; 250 8d nails; "Buttons &c to Negroe Sawney"; tobacco hogsheads inspection; German oznaburgs, linen "&c to Negroe Sawney"; medicine for fevers such as Jesuit Bark; and "Hatt &c to Sawney."[114]

Other slaves were distributed among Madison family members years after Colonel Madison's death. As directed by the will, his wife Nelly Conway Madison received her share of slaves. Later, she deeded a share of the slaves in January 1828 to her daughter Sarah, who had recently married Thomas Macon and still lived in Orange County.[115] Nelly Conway Madison received half of the house and kitchen furniture as her dower, first choice of the slaves that Colonel Madison had reserved in his own lot and the "tradesman Harry if she chooses to take him." Despite the appearance of an orderly distribution of property, the prevailing suspicion of slaves reemerged in Colonel Madison's will. For instance, he directed his executors and the guardian of his daughter Frances Taylor Madison, a minor, to "dispose of such of her slaves as they shall suspect may be in danger of being lost by runing away and not recovered again." With this statement, Colonel Madison seems to be admitting a tenuous control over his slaves.[116]

On the margins of Colonel Madison's plantation was the location of the slaves' burying ground, sited between the old Mount Pleasant quarter and Montpelier. To this day, it is still there. On the burials of their slaves,

the Madison family papers are silent. The Madisons left no record of their impressions of this piece of ground on their plantation—neither did the slaves. Located some distance from the Madison family cemetery along a farm road, the slaves' burying ground can be found in the woods and, on first glance, appears indistinguishable from the surrounding forest. Closer observation reveals depressions in the ground that follow the dimension of a human body, only some of them marked by field stones and a low earthen berm.[117]

Like the Montpelier slaves, slaves at Carter's Grove, a plantation on the James River in the Tidewater region, carved a similar space out of the woods there. Archaeological investigations at the Utopia quarter revealed east to west orientations in most, but not all, grave depressions. The same pattern occurs at Montpelier's slave cemetery. The Carter's Grove slaves were buried with selections of their African material culture, including glass bead necklaces and tobacco pipes.[118]

The Montpelier slaves' burying ground was one of their landscape signatures—a space of their own. Like the small garden plots Colonel Madison may have allowed them within the confines of their quarters, the burying ground was a constricted space circumscribed by a moral order imposed by the Madisons. African American burial practices on slave plantations show how African cultural forms were expressed in mortuary practices in the eighteenth and nineteenth centuries. In these instances, African Americans relied on traditional forms to constitute a proper burial. Grave goods and burial rituals on some plantations consisted of resilient African cultural forms that countered the oppressive world of plantation slavery. Grave goods included artifacts of personal importance to the deceased as well as surviving family members. Such relics served religious and decorative purposes by commemorating the deceased's passage to the world of the dead and by providing the survivors access to the potent mystery of that world. As an indication of that potency, slave burials rarely went unsupervised. Whites, out of fear of slaves assembling as a large group for any purpose, closely monitored graveside activities.[119] Ordinary objects placed in association with burial practices can compose a signification of meaning. For instance, allusions to water and whiteness, seen in the white quartz field stones placed on some grave depressions in Montpelier's slave cemetery, evoke a durable memorial. For Montpelier's slave community, as well as others in the region, burial grounds functioned as a threshold, mediating the boundary between the living and the dead. In order to mark their significance, slaves often placed burying grounds within sight of passing foot traffic, as they did at Montpelier. In this manner, the burying ground and its attendant rituals sustained the identity of Montpelier's slave community.[120]

A former Virginia slave recalled the burial activities at a Nansemond County plantation where he was born in 1850. This testimony shows the role of the white overseer, the inclusion of relics, clothes in this instance, from the deceased person in the burial ritual and the potency of the clothes. According to West Turner, "The ole overseer would go to de saw mill an' git a twelve inch board, shape it wid a point head and foot, an' dig a grave to fit it. Den he tie de body to de board. dan bring it in de hole to keep it from stinking. Slaves most de times dress de body in all his clothes 'cause wouldn't no one ever wear 'em. Whoever wear a dead man's clothes gonna die hisself real soon, dey used to say."[121]

Efforts to control and degrade the circumstances of a slave's burial were part of a larger practice of maintaining dominance in the slave-master relationship, while slaves attempted to control the symbolic expressions employed in the burial ritual.

The Madison family's slaves who left Montpelier for Woodley, Ambrose Madison's farm, did not go far from the burying ground of their ancestors. Sharing a boundary line with Montpelier, Woodley developed as a microcosm of Montpelier. The death of Ambrose in 1794 prompted an inventory of his estate that reflected the estate's development at that time. The inventory provides an indirect comparison of the Madisons' material world after the Revolution.

Slave labor supported a high level of refinement at Woodley. Ambrose Madison was taxed for twenty-seven slaves (not all of them adults), six horses and fourteen head of cattle in 1782. In addition to the original 350 acres, Ambrose Madison paid taxes on two tracts of 398 acres and 100 acres from 1787 until his death. He added 126 acres to his land holdings in 1793, a year before his death. The size of his estate peaked at 974 acres until his widow sold back to Colonel Madison a 100-acre tract in 1795.[122]

When he died, Ambrose owned thirty-nine slaves worth £1,220. The plantation's livestock included thirty-eight hogs, fifty-one sheep, forty-three head of cattle and two yoke of oxen. His family continued living in the frame house that featured a "Dressing Glass, Wrighting Desk, Book case," walnut chairs, fifteen tablecloths, window curtains, candlesticks, twenty-nine towels and "nine toilette cloths." The dining room was equipped with a case of knives and forks, pewter dishes and plates, a tea chest, silver flatware, four teapots, three cream pots, "10 Pickle Shells," "14 custard cups" and "35 Queen's China dishes." The bedrooms included mattresses, bed furniture, blankets, sheets and counterpanes. As they had at Montpelier, the Madisons of Woodley enjoyed all the accoutrements necessary for refined behavior.[123]

The presence of a loom, four pairs of cards, sheep shears and the sheep in Ambrose's inventory indicates the production of cloth by slaves. The

inventory also listed wheels for processing flax and cotton. Other tools that Woodely's field slaves would have used were described as "Plantation utensils with old Iron." Ambrose also owned a "still kettle & worme" for distilling, a seasonal activity on most farms in the region. Using "barr Iron," his slave blacksmith had constructed twelve casks and five "old Hhds" at the time of Ambrose's death. Other farm tools included a wheat fan and a cutting knife. Kitchen utensils included a coffee mill, milk pails, a churn, frying pans, flesh forks, a grindstone, a ladle and sugar tongs, a spice box and other necessary household items such as iron cookware and earthen pans.[124] The presence of a spice box, frying pans, a gridiron and two Dutch ovens in the inventory suggests the influence of continental cookery in the household.[125]

West of Woodley and Montpelier, Colonel Madison and his sons made more changes of a commercial nature to the Piedmont landscape by erecting a gristmill along the Rapidan River after the Revolution. Colonel Madison had built a custom mill on a creek close to Montpelier, but its operation was sporadic, operating only when there was adequate rainfall. For instance, he told a neighbor in August 1779 that he was unable to grind meal due to a lack of rain and asked him to "defer sending for any more as long as you conveniently can do without it, unless there comes Rain that I can grind it for you."[126] In partnership, Colonel Madison and his sons constructed a merchant mill after petitioning the county court for permission to dam the water in 1793. They formalized their partnership in July 1795.

The Madisons contracted with Adam Frailey to build the mill. Frailey had built a mill for Isaac Hite, a Madison in-law living in Frederick County, Virginia.[127] James Madison Jr. sold his New York State land investments to contribute to their merchant mill:

> As I retain the conviction I brought from home in favr. of the Mill at my brothers, I have been endeavoring to dispose of the piece of land on the Mohawk river….Notwithstanding these circumstances I am so much disposed to forward the plan of the Mill which I view as particularly favorable to the interest of my brothers as well as myself…if a pursuit of it depends essentially on my contribution, I shall not hesitate to make the sacrifice.[128]

James soon sold his Mohawk River Valley farmland and focused on the mill. Even on his honeymoon with Dolley at Hare Wood, he devoted time to the family project. He wrote to his father telling him that he had met with millwright Adam Frailey at the Hites' residence in Frederick County, and Frailey promised "stedfastly to be with you in about a fortnight at farthest; and to do every thing on his part requisite for a vigorous prosecution of the undertaking at Bernard's Ford."[129]

Madison kept his father apprised of construction at the mill. For instance, when Colonel Madison made a trip to the Healing Springs of Bath County, Virginia, in 1796, his son wrote:

> *I was down at the Mill yesterday & found the work going on properly. It is of importance however that the abutment should be well secured before much rain comes; as it is found that a small swell in the river will accumulate at the dam so as to overflow it; and as the dam is rather higher than the Bank of the river, the water in that case will be very troublesome to the unfinished work. Frailey had not returned, but several hands, Garten & others, had joined the force working on the Mill.*

In their new mill, the Madisons found an opportunity to exploit a better source of water power as well as another allocation of their growing enslaved labor force.[130] The mill project also placed the Madisons at the center of a local exchange network. Typically, only the wealthiest local families owned mills. Thus, they furthered their reputation as model farmers and leaders of rural society through improvements.[131]

When he died in 1801, Colonel Madison left a landscape profoundly rearranged from the one he knew as a young man. The thick woods of Spotsylvania County had become cultivated ground of Orange County. Montpelier now included mills, stills, an active smith shop, more slaves and quarters. Montpelier's neighbor, Woodley, also reflected the Madisons' prosperity despite the misfortune of his son Ambrose's death. Colonel Madison's life can be seen in his possessions: Biblical tracts and Christian literature, his account books and his brick mansion. Montpelier was his gift to his descendants. He endowed his widow with the right to occupy, "possess, and enjoy my mansion house and all the necessary slaves, Gardens, and yards appertaining thereto, with the accustomed liberty of getting timber and Wood for the use of the said plantation and Home without waste." He directed his executor to give his widow whatever grain she "has ground at my Mill." The 1801 inventory of his estate documents a mansion containing amenities at the ready: a backgammon table set, tea tables, carpets, looking glasses, magnifying glasses, an eight-day clock, a large library and three dozen walnut chairs with a variety of bottom treatments (flagged, leather, rush and hair bottoms). Compared to the inventory of his son Ambrose's estate, Colonel Madison's differed only in quantity. The family library included Biblical tracts, ecclesiastical literature and exegesis, but his attention had turned to medicine, as indicated by the large number of medical texts. The inventory of books included only one text on agricultural improvement essays, which was listed as "Bradley's Gent. & farmers guide."[132] This was

probably Richard Bradley's *Gentleman's and Gardener's Calendar*. Most planters usually owned only one volume on agriculture.[133]

The will contained the typical bequests of the day, but the mansion itself figured prominently in the instrument. In a perfunctory manner, Colonel Madison's wife and heirs received equal divisions of the residue of his estate. However, Montpelier, as if it were a living member of the family, received gifts from Colonel Madison too: a cabinet, a Turkish carpet, maps and pictures, "which belong to my Mansion House." By binding these things to the house, he intended "that those who have not been advanced in my life time shall have an equal share with those who have."[134] The house itself was part of his legacy. He sought to maintain Montpelier as the house of a gentleman and a monument to the wealth and visibility of the Madison family, prominent as revolutionaries and tobacco and grain exporters, slave owners, politicians and genteel individuals. Of these fine decorative accessories endowed to the house, the Turkish carpet would have drawn special notice as a sign of luxury. For instance, a Chesapeake agent for British tobacco merchants described the significance of Turkish carpets as a marker of the tobacco planters' conspicuous consumption habits. In 1766, John Wayles commented, "I don't remember to have seen such a thing as a turkey Carpet in the Country except a small thing in a bedchamber. Now nothing are so common as Turkey or Wilton Carpetts, the whole Furniture of the Roomes Elegant & Every Appearance of Opulence."[135]

After having endured the uncertainty of life on a frontier slave plantation in a slave community, depressed tobacco markets and a violent revolution, the Madisons had joined Virginia's elite tobacco planters, with Montpelier signifying their standing among the Virginia gentry.

Within ten years of the marriage of Colonel James Madison and Nelly Conway, the new house was complete. For Colonel James Madison, his two-story, double-pile, brick mansion with a center passage marked his induction into the social realm of Virginia gentlemen and their pretentious houses. The interior spaces featured accommodations to his new social and service demands. Through his marriage, he gained the labor of more slaves whose labor supported his elevated social status. The construction of a new house and the rearrangement of roads and fields at Colonel Madison's plantation characterized the improvements to this planter's prospect.

CHAPTER FOUR

The first modification of the house occurred when James Madison Jr. returned home with a family after his service in the Congress. The changes expressed both expedient and aesthetic values. Of course, with a new wife and stepson, he needed more living space. The new additions to the house included dining and kitchen spaces as well as a pedimented portico attached to the façade. Privacy and status motivated the changes, which resulted in a larger house projecting the sensibilities of the classical revival. The building campaign also united three prominent politicians on the cusp of dominance in the federal government. As they built their separate houses, Monroe, Madison and Jefferson shared the skills of local builders, building designs and political ideas. Although he entertained the thoughtful suggestions of Jefferson regarding the arrangement of space, Madison chose to follow conventional forms of building in Virginia throughout his construction campaigns.

Another building cycle occurred when James Madison Jr. entered the presidency. The changes to the house made during his presidency reflected increasing social and entertaining demands placed upon the house. In addition, the new building form resulted in a deep inscription of classical renaissance ideas on the house and grounds, in particular at the temple. The national prominence Madison achieved was translated into a further refinement of his house and grounds. The occasion of building again at Montpelier offered James Monroe and James Madison cause to rekindle their friendship and strengthen Madison's presidential administration as war with Britain drew close. Although Jefferson again offered building advice and skilled builders, Madison chose to decline the opportunity to make substantial changes according to Jefferson's design ideas. Therefore, the house and grounds reflected Madison's taste in architecture, rather than Jefferson's.

Previous studies of the house have attempted to amplify its significance by attributing the design and construction of its second phase to the notable

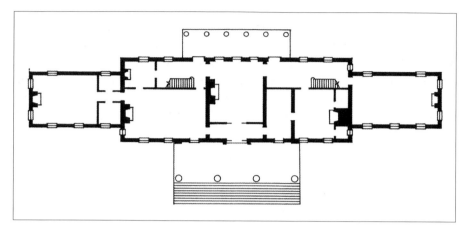

Speculative Montpelier floor plan in the 1830s. *Courtesy of Historic American Buildings Survey, Library of Congress, Prints and Photographs Division, Washington, D.C.*

early American architects Benjamin Henry Latrobe and Dr. William Thornton. Some have gone so far as to credit Pierre L'Enfant with designing a landscape for Madison. These efforts to attach the house and grounds to notable figures diminish the role of Madison himself, his family and his friends in arranging the house. More importantly, the design process in the first rebuilding phase, when then-Congressman Madison restyled his father's home during John Adams's presidency, emanated from political conflicts and wider collaboration with republican politicians—such as Thomas Jefferson, his brother William Madison and James Monroe—rather than the influence of a singular genius intellect/architect.

The landscape features, as well as the house, developed purposefully according to a utilitarian ideology that valued converting wilderness into commodity. There has always been a strong political concept activating the various building phases at Montpelier. The landscape that emerged in the 1730s at Mount Pleasant, with its expedient cluster of outbuildings, palings and family house, was discarded when the Madisons moved into a brick Georgian mansion as Colonel Madison moved up in the local public offices. Immediately, Montpelier bore the signature of status. It was a localized materialization of an ideal type, an archetypical manor house in the vernacular Georgian idiom. Colonel Madison, and then his son James, designed and redesigned the house and grounds to achieve material recognition of local authority, class dominance and public visibility.[136]

At the beginning of the nineteenth century, Montpelier emerged as a statement about President Madison. Both Jefferson and Washington loved their homes, devoting considerable attention to the details and the

problems of house building as they crafted personal and political statements in architecture. Madison loved his home too, but not to the extent of Washington or Jefferson. He did not lavish attention and expense on Montpelier as they did. He did not revel in the design process. He kept his building projects modest and serviceable. He did not build to get away from his mother, as some scholars suggest both Jefferson and Washington did. Rather, Madison built to stay within his family circle and to improve their living conditions. Madison's building projects were discreet and swift so as to minimize expense and inconvenience to his family. Once he was done with building in 1812, he was satisfied with his domestic arrangements.[137] Montpelier showcases his command not just of ancient republican forms of government, but also the architectural styles of antiquity. As such, Montpelier serves as part of a set piece of republican architecture seen by travelers from the North, when clerks, cabinet members and other distinguished visitors paused there on their way to President Jefferson at Monticello.

After his election to the presidency, Madison returned his attention to the appearance of Montpelier. With the opportunity to consult with Benjamin Henry Latrobe and Dr. William Thornton, who were eager to curry the president's favor, and the availability of skilled Philadelphia builders in the area—a rarity in Virginia—Madison refined the classical essence he sought to embed in Montpelier. James Dinsmore and John Nielson, craftsmen in Jefferson's service, brought a clearer Neo-classical finish and a new arrangement of living spaces to Montpelier. Acting on the availability of skilled labor in the neighborhood and sound advice, Madison distilled republican concepts into domestic architecture.

Architecture at Montpelier changed from a Colonial mode to a style republican in argument. Montpelier's new collection of decorative arts and lifestyle advanced the republican agrarianism ideology. Inspections of fields and flocks and dinner on fine French ceramics were symbolic components of the Montpelier visitor's experience. The service of meals and the accommodation of guests bore meaning as well. It took two building phases for Montpelier to fit Madison's republican outlook and produce the house and grounds he desired. The public experience of Montpelier was that of visiting a cultural production where republican ideology and material culture interacted to manifest the revolution, republicanism and the Union.

As a republican essay written in architecture on the Piedmont landscape, Montpelier expressed a Jeffersonian notion of virtuous national character developed through the building arts, rather than Madison's abstract conceptualization of a constitutional system of government that would secure a republican quality of life. Of course, both men shared these ideas, but this distinction, James Madison's faith in republican government and

virtuous agrarianism rather than architecture as the activating agent of national virtue, is reflected in the attenuated classical styling at Montpelier. Madison invested more attention in improving agricultural techniques and structures of government than in perfecting the building stock of America.

Of all Montpelier's occupants, President James Madison and his wife Dolley were the most widely known. His activities during the American Revolution, his role in the debates in the Constitutional Convention, his service in Congress, his service in the executive branch as Jefferson's secretary of state and his own presidential administration earned him a place among the pantheon of founding fathers. Biographers and scholars have investigated numerous aspects in his life, paying particular attention to his intellect and statecraft. His interests in architecture and landscape improvements, however, have been overlooked. The material record left in the house and grounds at Montpelier during Madison's lifetime provides an opportunity to know his temperament and connect him to the context of Piedmont Virginia elite culture at the end of the eighteenth century and the beginning of the nineteenth century.

In general, scholars have treated Madison as an encore of Thomas Jefferson. Recently, there has been an increasing focus on him as an individual, showing the effect he and his wife had on social life of Washington, D.C., and the United States' reputation as a civilized nation. However, some scholars place a heavy emphasis on the putative influence Palladio had on the designs Madison chose for his house. Actually, Montpelier owes very little to Palladio.[138]

Numerous biographies have endeavored to illuminate and animate Madison. Current work on Jeffersonian republicans emphasizes intellectual antecedents for the political programs advanced by Madison and Jefferson and the subtleties of civic republicanism in political and cultural debates of the day. Scholarship on republicanism portrays the concept as armature for maintaining virtue and morality rather than as a theory of government. The early focus of scholarship on the political and constitutional dimension of the republican ideology has been expanded to include political culture and social processes. In their discussion of American national character, Madison and Jefferson included architecture, which they intended to carry aspects of their republican ideology. Thus, their buildings reflected their political concerns, ranging from personal status to national character. In *The Last of the Fathers*, Drew McCoy devotes attention to Madison's efforts in his retirement to preserve the civic republican tradition against the burgeoning liberalism of the Jacksonian period. McCoy's intellectual biography examines the despair Madison experienced from the dilemma slavery presented to his notions of political economy and his republican

ideology. Ralph Ketcham's biography delineates Madison's entire life, with emphasis on Madison's intellectual influences and his role in the significant events of early American history. Irving Brant's six-volume analysis of Madison presents the legislative and executive aspect in Madison's life, with a particular focus on political and diplomatic intrigue. In general, the built environment—which is to say Montpelier, the farm, the crops, the slaves, the other farms of the Madison family, the houses, their furnishings—do not figure prominently in these biographies. Knowing Madison through Montpelier provides a new perspective on his social relations and private dilemmas.[139]

In the late 1790s, Madison began a transformation of Montpelier. The first changes were modest, a two-story attached addition and a rudimentary portico, but later there appeared elegant flourishes: a garden, a portico and a temple. The 1797–99 building phase was a social act, in that it involved Madison's friends and political allies. With assistance from Monroe and Jefferson, Madison worked through a moment of political adversity and the challenges of house building. While all three of them were disengaged from national government, they engaged themselves in architecture projects and developed a design charette that sustained their efforts in building and politics.

Madison's initial attempt at building took place off Montpelier's grounds. First, he built a house (presently the headmaster's residence at Woodberry Forest School in Madison County, Virginia) with his brother, William, who had married Frances Throckmorton in 1783. To improve the design before house building began, Madison asked Jefferson for advice, particularly on the rules of intercolumniation in 1793.[140] Jefferson responded with "some general notes on the plan of a house you inclosed." His response featured embellishments that reflect his own preferences. With this design in front of him, Jefferson "endeavored to throw the same area, the same extent of walls, the same number of rooms, & of the same sizes, into another form so as to offer a choice to the builder. Indeed I varied my plan by shewing what it would be with alcove bedrooms, to which I am much attached."[141] Madison gratefully acknowledged the usefulness of the advice, but it did not address the design for the public front of the house. He wrote, "Your plan is much approved & will be adopted by my brother." As for the façade, Madison wrote, "I was misunderstood in my enquiry as to the proper width of the Portico: I did not mean the proportion it ought to bear to the side of the House to which it is attached: but the interval between the columns & the side of the House; or the distance which the Pediment ought to project. If there be any fixt rule on this subject, I will thank you to intimate it in your next."[142]

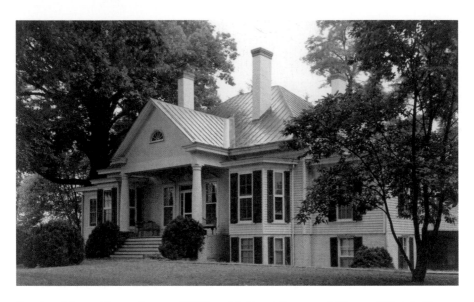

Facade of the residence, home of William Madison. *Courtesy of Library of Virginia Picture Collection, Richmond, Virginia.*

In the design of William's portico, we can see the Madison brothers reaching for the associative value of classical architectural order, a form unfamiliar to them. The house they grew up in did not feature such a façade. While not part of their own boyhood home, they more than likely saw such pedimented porticoes on homes in the area. With the changes in the social uses of the central passage came changes to the area of the façade that marked the entrance to such a hall. Yet assistance from Jefferson was crucial. In return correpsondence from Jefferson, Madison received a detailed explanation. Jefferson wrote, "A Portico may be from 5. to 10. diameters of the column deep, or projected from the building. If of more than 5. diameters there must be a column in the middle of each flank, since it must never be more than 5. diameters from the center to center of column. The portico of the Maison quarèe is 3 intercolonnations deep. I never saw as much to a private house."[143]

Madison was quite familiar with Jefferson's reference to the Maison Carrée at Nîmes from their correspondence in 1785 regarding the design of the state capitol at Richmond, but William did not intend to design such a monumentally proportioned house. From that conversation with Jefferson in 1785, Madison, who had attended legislative sessions in Williamsburg at the time of the Revolution, became aware of Jefferson's interest in building well, or building for the ages. Jefferson wrote to Madison that construction, which had started already, be halted in order to prepare the foundation for the

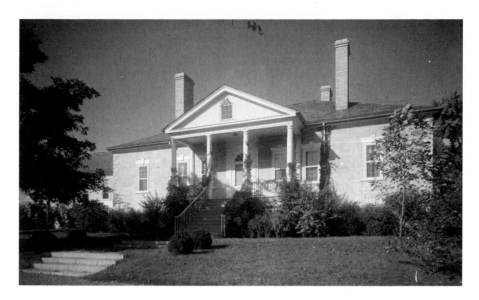

The facade of Belle Grove, Frederick County, Virginia. *Courtesy of Historic American Buildings Survey, Library of Congress, Prints and Photographs Division, Washington, D.C.*

design that Clerisseau had prepared. Writing from Paris, Jefferson prevailed upon Madison to make the case for the alternative design. Jefferson wrote to Madison, "How is a taste in this beautiful art [architecture] to be formed in our countrymen unless we avail ourselves of every occasion when public buildings are to be erected, of presenting to them models for their study and imitation?"[144]

Rather, the portico signified the Madison brothers' intention to make William's house a statement of his taste and his social standing. Indeed, William was moving up in the political world of his neighborhood: he represented Madison County in the Virginia legislature as a delegate in 1794 and on many occasions afterward. The Madison brothers' interest in a portico also stems from the new uses of the central hall.

Later, James Madison drew on Jefferson's reserve of architectural knowledge again for advice on behalf of another sibling in 1794. His sister Nelly and her husband Isaac Hite Jr. planned to build a new house in Frederick County west of Montpelier. Madison informed Jefferson in a letter that a Mr. Bond would be building "a large House" for the Hites. Madison suggested that Mr. Bond could visit Monticello "not only to profit of examples before his eyes, but to ask the favor of your advice on the plan of the House." The point of interest was, again, "the Bow-room & the Portico, as Mr. B. will explain to you." Madison added that he hoped for "in general, any hints which may occur to you for improving the plan."[145] Ultimately,

the Hites' house in its final form at Belle Grove did not adopt Jefferson's preferred alcoves or the broken façade treatment of a bow room, but it did feature a portico similar to the one on William's house. Furthermore, William's house did come to have the bow rooms breaking the plane of the façade wall. The emphasis that the Hites and William Madison placed on their porticoes illustrates a growing trend among wealthy Virginia planters who had begun using their central passages as articulated living spaces and employed the portico to punctuate that use.[146] Jefferson, however, seemed to be one step ahead of his neighbors with his polygonal bays and alcoves.

In 1796, the conversation between Madison and Jefferson on house building came to include James Monroe, who was in Paris as the American ambassador. Monroe wrote to Madison for advice on a new dwelling planned for his Highland plantation in Albemarle County. "Mr. Jefferson proposes to have a house built for me on my plantation near him, & to wh. I have agreed…For this purpose I am abt. to send 2. plans to him submitting both to his judgment, & contemplate accepting the offer of a skilful mason here, who wishes to emigrate & settle with us, to execute the work."[147]

As for Madison's part in the building of his house, Monroe wished that he and Mr. Joseph Jones—Monroe's uncle, a former member of the Virginia House of Burgesses and James Madison's colleague in the Continental Congress and Virginia House of Delegates—would "see the plans & council with Mr. Jefferson on the subject." As for Jefferson, Monroe gave him, since he lived adjacent to the tract, the authority to site the house and orchards.[148]

The prevailing climate of national politics, which did not favor the Jeffersonian republicans, influenced Monroe's decision to start plans for building a house. Based on his interpretation of the worsening political attitude in the Washington administration against France and his pro-French position, he thought he would be dismissed as an ambassador and back at home soon. "Believe me there is nothing about which I am more anxious to hear than that this plan is commenc'd and rapidly advancing, for be assured, admitting my own discretion is my only guide much time will not intervene before I am planted there myself."[149] Indeed, President Washington recalled Ambassador Monroe late in 1796.

Before building began at Montpelier, Madison acquired furnishings and household goods from France—further distancing himself from the aesthetic forms of Georgian Britain. Through Monroe, Madison received the domestic articles necessary for his new role as husband/stepfather and suitable to his republican ideology and its disdain for luxury. Monroe had offered to serve as Madison's purchasing agent in November 1794, soon after his arrival in France: "There are many things here which I think wod.

The Capitol at Williamsburg, Virginia, circa 1740. Detail from the Bodleian plate. *Courtesy of Library of Congress, Prints and Photographs Division, Washington, D.C.*

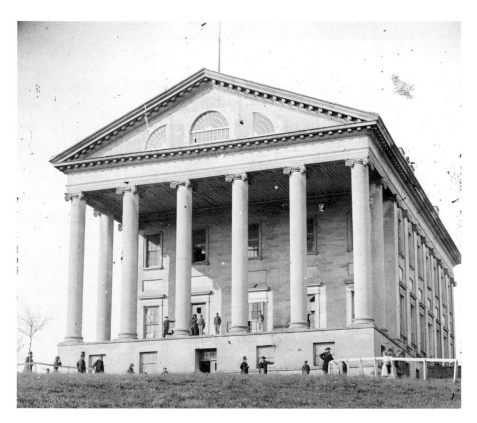

Front view of the capitol at Richmond. *Courtesy of Selected Civil War Photographs, 1861–65, Library of Congress, Prints and Photographs Division, Washington, D.C.*

suit you. I beg you to give me a list of what you want, such as clocks carpets glass furniture table linnen &ca.—they are cheaper infinitely than with you considering I have advantage of the exchge."[150] Madison soon placed an order, "as it is probable that many articles of furniture at second hand, may be had in Paris, which cannot be had here of equal quality, but at a forbidding price."[151] Monroe shipped a complete bed trimmed in crimson damask "a la Polonaise," another bedstead and mattresses, silk curtains for six windows and two Persian carpets.[152] The goods, wrote Madison, "lay us under very great obligations to your kindness, and are the more valuable, as we venture to consider them as bearing the sanction of Mrs. Monroe's taste as well as yours."[153] Madison, anticipating retirement from Congress, placed another order with Monroe: "If you can procure a Chimney clock for me, within reasonable limits I will thank you to do so, sending it however to Fredericksburg (not this place)."[154] Madison's pursuit of French furnishings reflects a longstanding trend of American interest in French decorative arts, dating back to the seventeenth century. The exchanges between Monroe and Madison were part of a growing dissemination of French styles in the United States.[155]

The Madisons returned to Montpelier in the spring of 1797 and began organizing the household and building materials. Life in Philadelphia had been good for Madison, but Dolley Payne Todd experienced grief. In Phildelphia when she was a young girl, her father had struggled to find success in business. His starchmaking venture failed, and he died in 1792. Her life as a married mother of two children ended in 1793. Yellow fever took her husband, her in-laws and one of her children. Meeting James Madison revived her life. In 1794, they were married at Hare Wood, the Virginia plantation home of her sister Lucy, who had married Steptoe Washington.[156] The shipment of his and Dolley's personal property from Philadelphia included Windsor chairs, mahogany chairs, other items in numbered trunks and boxes as well as "20 Bundles Nail Rods.—1 Billet wood."[157] Building began in the early summer of 1797. By the end of the year, Madison had received a response from a Philadelphia marble merchant about the cost of an imported Italian chimney piece.[158]

After the building projects of his brother and sister, Madison turned to his own house building and farm improvements out of political exasperation. He had retired from the House of Representatives in 1797, frustrated by the policies of Federalist president John Adams. Sharp partisan politics pushed Madison away from his early nationalist positions. The Adams administration's hostility to the French Revolution and tolerance of the Quasi War offended his pro-French sympathies. In the nascent Hamiltonian commercial formations of a national bank, national debt, a ministerial form

of government and a standing army, Madison recognized corruption. From Madison's point of view, according to Ketcham, "Hamilton had saddled the country with a financial system suited to speculation and intrigue, not simple republicanism."[159] James Monroe, relieved of his ambassadorial status, summarized the current state of affairs for Jeffersonian republican partisans such as Madison and himself in America: "I have read the speech & replies, & really begin to entertain serious doubts whether this is the country we inhabited 12. or 15. years ago: whether we have not by some accident been thrown to another region of the globe, or even some other planet, for every thing we see or hear of the political kind seems strange & quite unlike what we used to see."[160]

Timothy Pickering had acted in a way similar to Madison and Monroe when John Adams dismissed him as secretary of state in 1800. Finding himself out of the government, he returned to a Massachusetts farm to fulfill "my desire to be an improving farmer." Likewise, Fisher Ames farmed as a means of occupying his time in a socially acceptable manner while out of government after 1796. Ames kept up an exchange of agricultural advice with his allies in the so-called "Essex Junto" as they kept up their criticism of Madison and Jefferson and despaired over the decline of America into democracy. For both sides of the political battles, estate improvements provided a diversion from the bitter partisan disputes and an opportunity for companionship among like-minded friends.[161]

Monroe, Madison and Jefferson, however, laid a heavier emphasis on architecture than did the aforementioned New England Federalists. Furthermore, Monroe's new cargo of French goods added an *au courant* cast to their exchanges. As these Virginians struggled to make sense of their place in a Federalist world, architecture figured more prominently than agriculture in their correspondence due to Madison's and Monroe's immediate need for larger accommodations and Jefferson's Monticello rebuilding project, which was underway already.[162] Monroe, who was building a new house, wrote to Madison, who was adding on to an existing building, to petition again for his involvement: "I am projecting at my other place abt. a house, & wod. be glad of yr. aid."[163] Their discussions moved from building projects to politics. In addition to their consultations on domestic architecture, Madison and Monroe crafted resolutions in support of the French Revolution and positioned themselves for elected offices in Richmond (Madison won a seat in the House of Delegates and Monroe won the governorship in 1799). Political thoughts usually accompanied building advice, requests and invoices for supplies. For instance, their correspondence shows that Jefferson finished a 1798 letter to Madison concerning the availability of workmen with, "I inclose you a copy of the draught of the Kentuckey resolves."[164]

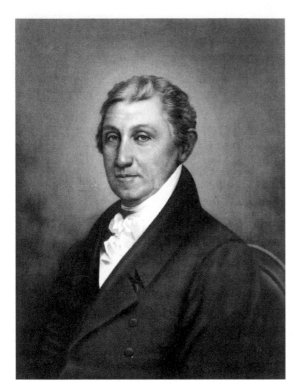

James Monroe. Engraving
from John Vanderlyn, circa
1835. *Courtesy of Library of
Congress, Prints and Photographs
Division, Washington, D.C.*

Jefferson and Madison found themselves in conflict over workmen in 1798. Jefferson requested that Madison not call for Richardson, a mason, "because that gives us another post-day to warn you of any unexpected delays in winding up his work here for the season, which, tho' I do not foresee, may yet happen."[165] In fact, Richardson was delayed until November. Jefferson explained that he "has been in a great measure prevented from doing any thing this week," due to the weather, which became "too cold for laying mortar." That problem left Richardson about "2. or 3. days work of that kind to do, which is indispensable, and about as long a job in kilning some bricks which we must secure in an unburnt state through the winter." So Jefferson prevailed upon Madison for patience: "We must therefore beg you to put off sending for him till Saturday next."[166]

Madison also requested Jefferson's forbearance in the release of L. Whitten, a carpenter who was laying floor boards at Montpelier. In his reply, Jefferson asked, "When will Whitton [*sic*] be done with you? Or could you by any means dispense with his services till I set out for Philadelphia? My floors can only be laid while I am at home, and I cannot get a workman here. Perhaps you have some other with you or near you who could go on with your work till his return to you."[167] Madison replied that it was "impossible"

Dolley Payne Madison. Engraving based on Gilbert Stuart's portrait. *Courtesy of Library of Congress, Prints and Photographs Division, Washington, D.C.*

to spare Whitten. "He has been under the spur to keep the way prepared for the Plasterers, and to finish off a number of indispensable jobbs always overlooked till the execution is called for."[168]

Scheduling workmen was not their only problem. Acquiring materials proved to be another challenge. Although Jefferson promised that "all the nails you desire can be furnished from Monticello,"[169] Madison had to augment the nails produced by Jefferson's slaves with nails made by his father's enslaved blacksmiths at Montpelier.[170] The necessity of using two sources was partly due to Madison's large order from Jefferson's "Nailory": "50,000 sixes, 3,000. eights, 20,000 tens, 5,000 twentys, & 12,000 flooring Brads. I shall also want 50,000. fours for lathing, 4,000 sprigs sixes, & 3,000 do. eights."[171] Jefferson's nailory produced the nails in the summer of 1799.

Although the sources come to us through the writings of men, the sources do show that house building was not just a man's project. Dolley Madison contributed her knowledge when Jefferson asked about a workman skilled in plastering: "Mrs. Madison tells me that Lumsden, your plaisterer lives about 10. or 15. miles from you & that an opportunity may perhaps be found of conveying him a letter. I trouble you with one, open, which when read, be

so good as to seal & forward by any opportunity you approve."[172] Dolley also transported nails from Monticello back home after visiting her relatives who lived near there.[173]

The correpsondence between Madison and Monroe indicates the early stages in the formation of their relationship in the exchanges of indebtedness and advice. House building demanded a ready supply of cash, and Monroe assisted Madison by reimbursing him for any debts owed to him at the time, "in case you are press'd as you may be by the expence of building."[174] Madison, in return, recommended that Monroe hire a Montpelier builder, Reuben Chewning, who "will, I am persuaded, justify all I have said in his favor."

Madison provided Monroe with a Montpelier progress report in November 1798: "I have met with some mortifying delays in finishing off the last shaft of the Chimneys, and in setting about the plaistering Jobb. The prospect is at present flattering, and I shall lose no time in letting you know that we are ready to welcome Mrs. M. & yourself to our habitation."[175] In December 1798, Madison left Montpelier, but upon his return he found himself "in the vortex of Housebuilding in its most hurried stage."[176]

Through his recent building projects with family and friends, Madison had been building up his architectural knowledge. Now his acquaintences were turning to him for guidance. Monroe sought out Madison's advice in the summer of 1799. Monroe asked, "Cannot you come up & stay a day or two with us. Yr. skill in architecture & farming wod. be of great use to me at present. I am much ingaged in both & take more interest, especially in the latter, tho' under discouraging circumstances, than at any former time."[177] Unfortunately for Monroe, Madison had become too busy at Montpelier. He declined Monroe's invitation to observe the building project underway at Highland in the summer of 1799. Madison expressed his regret this way: "It would give me the sincerest pleasure to ride up & see you, & I had almost determined to have allotted this week for the purpose; but some particular jobbs about the finish'g of my building made my presence indispensable: and there are others to succeed which make it uncertain when I shall be able to go from home."[178]

More French household goods and furnishings, which were available through the Monroes, accompanied the wagon sent with the nails. Madison wrote to Monroe that the wagon "will receive the few articles which you have been so good as to offer from the superfluities of your stock." The provision from the Monroes included "2 table cloths for a dining room of abt. 18 feet; 2. 3 or 4. as may be convenient, for a more limited scale, 4 dozen Napkins, which will not in the least be objectionable for having been used, and 2 Matrasses."[179]

When they did have an opportunity to enjoy each other's company, politics were discussed along with the demands of building. For instance, Monroe visited Montpelier in April 1798 on his way to the court in Fredericksburg. At that time they spoke about Franco-American relations and public sentiment in Virginia, which they felt was "unquestionably opposed to every measure that may increase the danger of war." In a letter, Madison related their conversation about "the improper views of our own Executive Party" to Jefferson, who was then in Philadelphia, adding that he hoped Jefferson could send building supplies. He hesitated to prevail upon Jefferson, but the necessary building materials, which were "so important to my present object," forced Madison to "break thro' every restraint from adding to the trouble of which you have more than enough." For Montpelier, he wanted panes of window glass, brass locks, screws and hinges for eight doors.[180]

Then, as work progressed at Montpelier, an opportunity arose for a visit to the Monroes. In late 1799, James and Dolley Madison finally made their promised visit to the Monroes at Highland. Monroe, however, warned them, "Our house is unfinished in all respects, the yard in confusion, &ca, but you shall have a warm chamber & be made as comfortable as we can make you."[181]

As the work at Montpelier neared completion, other problems arose. So Madison sought more advice from Jefferson. The finish coat for the portico columns concerned him. So he asked Jefferson, "Will [you] oblige me by enquiring whether there be known in Philada. any composition for encrusting Brick that will effectually stand the weather; and particularly what is thought of common plaister thickly painted with White lead overspread with sand. I wish to give some such dressing to the columns of my Portico, & to lessen as much as possible the risk of the experiment."[182]

The advice came a month later: "I spoke on the subject with W. Hamilton of the Woodlands who has skill & experience on the subject. From him I got only that common plaister would not do. He whitewashes his brickwork." Furthermore, Jefferson noted that, "In Ld. Burlington's edition of Palladio he tells us that most of the columns of those fine buildings erected by Palladio are of brick covered with stucco, & stand perfectly." This mention of Palladio in the late stages of the project is significant. The Palladio reference here is the first occurrence of his name in their correspondence concerning building. For the first time, the influence of elite European designs on Montpelier can be traced into what had been essentially regional Virginia Piedmont building plans utilizing local materials in Madison's other building projects, such as wood framing for William Madison's house and stone masonry of available limestone for Belle Grove. Stucco-covered columns arguably are the only Palladian influence on the house, if at all.

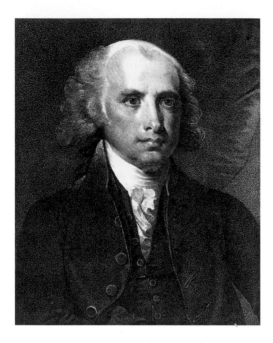

James Madison, fourth president of the United States, lithograph based on a Gilbert Stuart portrait. *Courtesy of Library of Congress, Prints and Photographs Division, Washington, D.C.*

Rather than reflecting the designs of Palladio, the house reflects Madison's own taste and expression of regional domestic architectural trends.

As for Madison's problem with coating his columns, Jefferson again drew on his study of French architecture. "I know that three fourths of the houses in Paris are covered with plaister & never saw any decay in it. I never enquired into it's composition; but as they have a mountain of plaister of Paris adjoining the town, I presume it to be of that." He suggested that "a coat of the thickness of a knife blade would do on brick, which would cost little. I presume your plaisterer Wash could do it well."[183]

In the settlement of his nail account with Jefferson, Madison described certain aspects of the previous year's work, which are helpful in assessing the progress of the project through time. For instance, he wrote, "The floor of the Portico was laid with brads made in my father's shop, and a remainder of the Stock procured the preceding year." He recalled the help of Mrs. Madison, and "the driver of my carriage, who brought [the nails] down in Augst." He specified that "apart of [the nails] were used in lathing the Ceiling of the Portico."[184] Some additional work was done by Reuben Chewning in 1800, when he put a new roof on a porch.[185]

After 1799, Montpelier had a new, three-bay-wide, two-bay-deep, two-story brick domestic segment for James and Dolley Madison's living quarters appended to the northern wall of the original mansion. Madison obscured the interface between old and new, where the new brick walls

joined the older façade, with a full-height portico. Now seven bays wide, the dwelling featured a pedimented portico *a la mode* advancing from the façade. While the transformation evoked classical symbolism (a reference to Roman temples perhaps), social and utilitarian concerns motivated the changes. The addition to the house provided James Madison Jr. and his family with sufficient space (a dining room, a parlor, a kitchen of their own and bedrooms upstairs) adjacent to the existing house still occupied by his parents and younger siblings. Of course, the pedimented portico differentiated the Madisons' house from the residences of their neighbors, especially those lower in any economic ranking, but the pedimented portico's appearance at Montpelier was in keeping with decorative systems employed by his fellow Virginians, those of the upper ranks. The arrival of pedimented porticos on eighteenth-century Virginia houses typically followed a reallocation of interior space rather than a reading of Palladio or an intention to broadcast strict classical forms. Porticos emerged at this time as an architectural coda to, or a frame for, the internal change occurring in the use of central passages, which had grown in importance as articulated, ornamented living spaces. Porticos punctuated the social use of this space inasmuch as they served as icons of status.[186]

In a way, the pedimented portico announced changes to the interior of Montpelier that included, among other things, the display of Madison's growing art collection, consisting of busts of George Washington and Paul Jones, and his newly acquired French consumer goods.[187] A visitor to Montpelier at about this time described the new arrangements. Mrs. Anna Marie Thornton, wife of the architect and civil servant William Thornton, who designed the U.S. Capitol and administered the Patent Office, complimented Madison on his house for "displaying a taste for the arts which is rarely to be found in such retired and remote situations." She noted that the two Madison families, meaning the households of Dolley and James and then James's father and mother, "dine under the same roof, tho' they keep separate tables." She described the Montpelier landscape in conventional terms as "picturesque." She wrote that Montpelier stands "on a height commanding an extensive view of the blue ridge, which by the constant variation in the appearance of the clouds, and consequently of the mountains form a very agreeable and varied object, sometimes appearing very distant, sometimes much separated and distinct and often rolling like waves." Although the vistas lacked a water feature, Mrs. Thornton admitted that after Madison made other improvements, "it will be a handsome place and approach very much in similarity to some of the elegant seats in England of which many beautiful views are given in Sandby's views, etc." The Thorntons also dined at William Madison's house. As another

compliment to the skills in building of the Madison brothers, she noted that "he has a fine plantation."[188]

After the Thorntons' visit, the British Minister Sir Augustus John Foster arrived at Montpelier the following year. Foster was forthright in his description. Foster's comments describe his opinion of the results of Madison acting as his own architect. Unlike Mrs. Thornton, who was pleased with the architectural style of James and William Madison, Foster found their work at Montpelier (he did not leave any comments on William's house) to be undistinguished.

> *Mr. Madison himself superintended the Building which he had executed by the Hands of common workmen to whom he prescribed the Proportions to be observed. It is of brick which requires and is intended to be plastered. It occupies about a Third part of the Length of the House, being 47 feet wide, and together with its Pediments it is as high as the house, viz. forty feet. There are four Columns to this Portico, of common bricks diminishing from a third, and having Bases as well as Plinths: and I mention it as being a Specimen of very plain, and, except that I object to Plinths, of good and massive Doric, which was executed by a Proprietor without the assistance of an Architect and of very ordinary Materials: but he had cases made for the Shape of the Pillars, of wood, and filled them up with mortar and bricks according to measure.*[189]

At the time of his visit, Foster saw the plantation when the grounds were still unimproved. Foster observed "some very fine woods about Mont Pelier [*sic*], but no Pleasure Grounds, though Mr. Madison talks of some Day laying out Space for an English Park, which he might render very beautiful from the easy graceful descent of his Hills into the Plains below." Foster compared the Montpelier landscape to Mount Vernon, which "did not seem to be very well kept up." The house and grounds were part of his impression of Madison, which he recorded: "No man had a higher Reputation among his acquaintance for Probity and a good honourable Feeling, while he was allowed on all Sides to be a Gentleman in his manners as well as a Man of Public Virtue."[190] Montpelier remained in this form throughout Madison's service as secretary of state in Jefferson's presidential administration.

The slaves' work routines did not change significantly after building the addition to Montpelier. They planted new specimens of plants given to Madison by foreign officers and dignitaries. They took care of Madison's grounds and goods, including imported wine meant for the table in the mansion, such as "Brasil wine and Citron" and Madeira, which, according to Madison's agent in Norfolk, Virginia, was "cased as you desired & is very

fine so is the brandy & Sherry having got some very old."[191] Along with the appearance of the mansion, Foster noted the slaves' activity, as well as the constraints on their living arrangements on three plantations that made up Montpelier, located not far from each other. He recorded that these three farms produced mainly tobacco and corn. As for the slaves working those farms, he wrote, "The Negro Habitations are separate from the Dwelling House both here and all over Virginia, and they form a kind of village as each Negro family would like, if they were allowed it, to live in a House by themselves." He also commented on the apparent self-sufficiency of the plantation based on slave labor: "When at a distance from any Town it is necessary they [the slaves] should be able to do all kind of handiwork; and accordingly, at Mont Pellier [sic] I found a forge, a turner's Shop, a Carpenter and wheelwright. All articles too that are wanted for Farming or the use of the House were made on the Spot, and I saw a very well constructed Waggon that had just been compleated."[192]

While the slaves' work patterns remained much the same as the house and grounds grew larger, their opportunities for legal manumission changed considerably after Gabriel's Rebellion in 1800. In response to the conspiracy centered in Richmond, the general assembly passed legislation restricting private manumissions and the movement of slaves from plantation to plantation. Although slaves could be emancipated privately through deed or will, the law demanded that they move out of Virginia within a year of their manumission or be subject to re-enslavement. The practice of hiring out slaves was prohibited in certain counties, particularly those around Richmond, where Gabriel Prosser had organized most of his support. The general assembly briefly considered measures for legalizing gradual abolition, followed immediately by transportation of the manumitted slave out of Virginia to an undesignated colony, but when a suitable colony could not be located, the debate turned in favor of tighter restrictions on slavery so as to keep it in place and under control.[193] Not surprisingly then, there are no records of private manumissions at Montpelier during this time of improvements to the plantation.

CHAPTER FIVE

Madison's election to the presidency in 1808 brought another round of changes to Montpelier. This phase of building raised the level of finish in interior spaces, added more private chambers and included another gesture toward elegant architecture. The renewed formal elements of the house further emphasized the house's character as the residence of a man of public authority. Previously, Madison had demonstrated his basic agreement with Thomas Jefferson on the need for improved forms of public architecture. In their estimation, the promotion of civic decorum and liberal education were essential to a virtuous national character in a representative democracy. Madison had followed Jefferson's aesthetic trajectory when it came to porticoes and the state capital, but he declined to make Montpelier into a grand architectural statement on the level of Monticello. His involvement, modest though it may have been, in the capitol at Richmond had exposed Madison to European design ideas and the antecedents from antiquity for classical architecture. His house, however, maintained a conventional regional character. On the lawn though, a modest classical revival temple did appear. Overall, republican simplicity prevailed at Montpelier.

While Jefferson demonstrated a keen interest in the aesthetic forms of antiquity and classical revival, Madison devoted his intellectual inquiries to the politics and governmental forms of the ancients. The simplified, restrained and incremental development of his house testified to a measured and frugal experimentation with classical revival trends in architecture. His notes on ancient and modern confederacies demonstrate his primary interest in antiquity—forms of government rather than building forms. Although Jefferson contributed to this redesign of Montpelier, the house is not one of Jefferson's other buildings.[194] Madison's own thinking on architecture led to changes at the mansion that were symbolic, yet sensible and functional. This building project, like the one in the 1790s, focused on

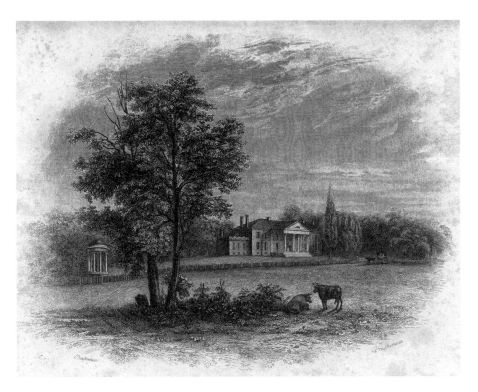

President Madison's house, Orange County, Virginia, 1836. Prud'homme (after Chapman). *Courtesy of Picture Collection, Library of Virginia, Richmond.*

the allocation of interior space with a concern for his family's convenience and privacy. Exterior treatments were modest. He limited his symbolic architectural statement to a single landscape feature—the temple.

In this phase of building at Montpelier, Madison's character as the overseerer of the builing project comes into clearer focus. We can see him directing workmen, deciding on measurements and ordering building supplies, as with the roof over the wings that were being added on required sheet iron for the gutters. Dinsmore asked Madison to decide on the dimensions and treatment of the roof.[195] Madison replied with the information Dinsmore needed and later shipped the materials: "Sir…the width of the Sheets of Iron, is 18 inches or so near it as that you may proceed on that calculation."[196] Madison disregarded his craftsmen's (and Jefferson's) advice for interior aesthetic enhancements on two occasions. First, Jefferson encouraged Madison early on in the project "to throw the middle room between your two passages out into a bow on the South side, taking a little from the passages to give it breadth, and with or without a portico there as you please. It will be somewhat in the manner of my parlour."[197]

Jefferson had in mind an apse or a semicircular projecting central salon, but Madison declined the suggestion. Secondly, James Dinsmore proposed an alteration to the ceiling height in the central hall by raising "the upper Joist a foot or eighteen inches & give that Much More height to the Ceiling of the Dineing room, it is at present too low for the finish we wish to adopt over the doors & Side lights & will appear Still lower when the room Comes to be enlarged." He assured Madison that "the rooms above will answer the Same purpose as ever the only disadvantage will be a Step or two into them—and the additional expence will not be great as we will have to take down the partition above at any rate to put in a trussed one to Support the girder; you will please to let us know whether you approve of it as Soon as Convenient."[198] The response was prompt and negative. Dinsmore submitted to Madison's wishes: "I received by Sundays Mail your favour of the 12th inst. and Shall accordingly accommodate our work to the present height of the Ceiling."[199] Madison chose not to make the hall and dining room conform to molding of academically correct proportions or the dimensions of Jefferson's parlor. So Montpelier should not be seen as another of Jefferson's buildings. Rather, it reflects the Madison family's history of building.

The temple design, however, is Montpelier's prominent architectural flourish that can be regarded as a Jeffersonian structure. It was the work of James Dinsmore and John Neilson based on ideas they may have discussed with Jefferson, who had designed other ornamental garden buildings for Monticello.[200] Of all the threads in Montpelier's architectural fabric, the temple marks Madison's clearest gesture to represent classical architecture. As an ornamental feature given a privileged position in the landscape, the temple projects the associative imagery of antiquity and the notion of architecture as a national asset. It was immediately visible to those approaching from the public road, which was closer to the mansion than it is today. It also served as a protective covering for an icehouse. Dinsmore and Neilson constructed an open-sided temple with a door in the floor to provide access to the ice stored beneath. Tuscan order columns support a hemispherical roof. The temple features an entablature with 117 feet of "frieze & Architrave." Over the cornice they installed a protective layer of copper sheeting that served as a drip edge directing water off the entablature. When approaching the mansion the temple stood on its left flank, while a brick pad parterre took a similar position on the right flank closest to the southwest wing.[201]

Along with the skilled workmen Jefferson sent to Madison from Monticello, Madison also contracted with Jefferson for the services of other Monticello laborers. In one documented instance, Madison purchased from

Jefferson the indenture of John Freeman in 1809. John Freeman, who may have assisted Dinsmore and Neilson at Monticello, arrived at Montpelier in April. The correspondence between Jefferson and Madison does not describe John Freeman's specific building skills. The sale of the indenture suggests that Madison did not rely exclusively on his own slaves to supply the necessary unskilled labor.[202]

Views from the house were also considered in the remodeling of the building and the placement of the temple. For instance, Madison envisioned the temple as a component of the library located inside the house. As they began work on the library, Dinsmore suggested in 1809 that they "put two windows in the end of the library room," because "without them the wall will have a very Dead appearance, and there will be no direct View towards the temple Should you ever build one."[203] Additionally, another visitor described the library and its "plain cases, not only around the room, but in the middle with just sufficient room to pass between; these cases were well filled with books, pamphlets, papers, all, every thing of interest to our country before and since the Revolution."[204] A visitor in 1816 described the view of the surrounding landscape from the roof above the wings. The Frenchman, Baron de Montlezun, stayed in a room with a terrace attached to it. The terrace allowed him to take in the rooftop view of the mountains to the west. "I can glimpse over the tops of the forest an immense plain whose fertile terrain, strewn here and there with hillocks, gradually lifts its successive levels, variously tinted, up to the romantic and misty masses which outline their semicircular amphitheatre against the horizon."[205]

Other changes included refinements and repairs to the basement kitchen, bedchambers, dining room, drawing room, alterations of the portico and the construction of a rear colonnade. The drawing room and passage (taken from the original house's hall and back room) composed the new central reception rooms on axis with the entry and the rear doors. New architectural detailing on the interior wall surfaces included "95 ft. run[ning] Cornice...4 extra Miters...193 ft rung of Architrave & Qrounds [quarter rounds]," five sets of blocks for the door or window architrave, "Curb round [the] hearth...57 ft rung of Base and Surbase" and a door head pediment carved in wood. The base and surbase in the account suggest the presence of chair board attached to the walls of this room. Changes to the fenestration included "framed window jambs & Sof[f]its with astr[a]gals on the panels" and treble sash frames for windows of thirty-six lights, opening this formal reception room onto the rear colonnade facing eastward. These triple-hung, wood sash windows also received "3 Setts of beads." They enhanced the decorative finish of the door openings of this room with an astragal profile in the molding that encased the door jambs. Dinsmore and Neilson installed

President Thomas Jefferson, Charles Balthazar Julien Fevret de Saint-Memim, 1804. *Courtesy of Library of Congress, Prints and Photographs Division, Washington, D.C.*

two "Venetian Doors with Side lights" for the main entrance to the house. In the drawing room, they installed three pairs of "moveable Venetian Blinds" for the windows, and they built two seats for the front portico.[206] Madison's social use of these spaces influenced these refinements.

A two-stage entrance arrangement now welcomed visitors to Montpelier: a narrow entry and a drawing room. George Shattuck Jr. stepped into this narrow entry in 1835 and noted the duplex character of the house. He recalled, "In front there are three yellow doors. The middle one opens into a narrow entry…There are doors from this entry communicating with the entries of each side." Once inside the narrow entry he found doors under both arches leading to the rooms on either side of the entry space. After moving forward from the entry into the drawing room, he entered into "a large parlor in which there are three windows to the east, reaching down to the floor and opening upon a piazza and so upon the lawn."[207]

Visitors commented on the new traffic pattern produced by the renovation. When Margaret Bayard Smith and her husband arrived in August 1809, President Madison greeted them and led them to his dining room, "where some gentlemen were still smoking segars and drinking wine." Then Mrs. Madison made her entrance, and "after embracing me, took my hand, saying with a smile, I will take you out of this smoke to a pleasanter room." Mrs. Smith added, "She took me thro' the tea room to her chamber which opens from it." Informality and comfort prevailed in Dolley's private

chambers. Mrs. Smith wrote, "I was going to take my seat on the sopha, but she said I must lay down by her on her bed, and rest myself, she loosened my riding habit, took off my bonnet, and we threw ourselves on her bed." In this relaxed position, they were served by the house slaves some "wine, ice, punch and delightful pine-apples."[208]

The creation of more privacy for the Madisons was in step with the trend followed by other elite Virginians. At that time, elites began further distancing their private spaces from the zones of public circulation in reaction to social and political changes associated with the democratization of the country. Some scholars have argued that the wings on eighteenth-century domestic buildings in Virginia owed more to prosperity and a local trend of divorcing public from private spaces than concerns for an academically correct Palladian silhouette. Elite Virginians modified rooms according to new demands on the house as a private environment buffered from the social environment that was shedding its former expectations of obeisance and deference. As a result, bedchambers were often pushed away from the hall, parlor or saloon. Separate exterior doors from the chambers allowed for discreet movement in and out of the rooms. Certain interior spaces were allocated for visitors or servants whose lower rank denied them access to more private zones of the house. After the renovation work, Montpelier's new floor plan provided more privacy within chambers on the periphery of the circulation system.[209] This new layer to the architectural fabric of pretentious homes expressed the decisions builders and planters made to resolve incongruities in their public and inner lives at a time of immediate social change. For the Madisons, increasing prominence, rather than prosperity, motivated changes to balance family life and social imperatives.

Adding wings to houses gained popularity within elite Piedmont culture, especially among members of Madison's social circle. The influence of Montpelier's floor plan and massing were apparent in Estouteville and Oak Hill, the homes of John Coles and James Monroe, respectively. These two houses offer contemporaneous comparisons to Montpelier and suggest that Montpelier may have served as a model for their construction. John Coles replicated Montpelier's form and massing with the assistance of James Dinsmore in 1830 at Estouteville. Located in Albemarle County, Estouteville had a cellar corridor for the passage of servants underneath the living spaces of the owners. The central pavilion carried the same Tuscan order, tympanum lunette window treatment and intercolumniation in its portico as Montpelier. The rear of Estouteville also featured a colonnade identical to Montpelier's. Flanking the two-story central block stood one-story wings with three bays each. The interior followed Montpelier's floor

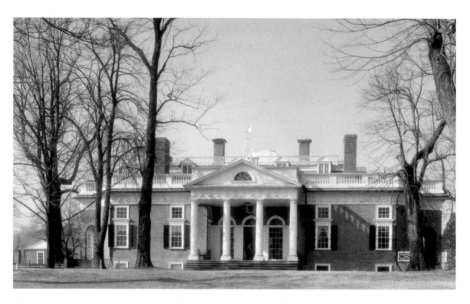

Monticello, circa 1900. *Courtesy of Detroit Publishing Company Photograph Collection, Library of Congress, Prints and Photographs Division, Washington, D.C.*

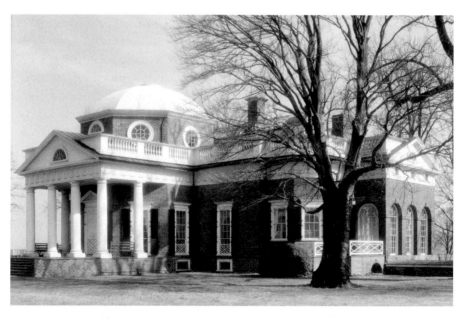

Monticello, circa 1900. *Courtesy of Detroit Publishing Company Photograph Collection, Library of Congress, Prints and Photographs Division, Washington, D.C.*

plan in general, but it was unencumbered by the relics of earlier building phases, as was the case at Montpelier. The central hall, which the Coles called a "summer living room," constituted the central axis of the house with an intersecting transverse corridor placed to the rear of the room, opening upon the rear colonnade.[210]

Montpelier's form and floor plan also inspired James Monroe when he built a grand architectural statement in Loudoun County between 1822 and 1823. Replicating Montpelier's Tuscan order portico, Oak Hill featured a prominent Tuscan order portico on its southern façade, with modillion blocks articulating the pediment and a fanlight in the tympanum. The portico stood above a cryptoporticus and along the central axis of the house, which provided space for domestic service as well as support for the portico. On the northern façade, an elegant frontispiece of fanlight, sidelights, engaged columns and double-leaf door—all recessed behind a large compass arch—provided access to the formal entry of the dwelling. A transverse corridor intersected the main axis created by the central hall. Beyond the corridor stood a highly fashionable double parlor. The transverse corridor allowed for a smooth flow between served and service spaces on the principal entertaining floor. In addition to similarities in plan and elevation, Dinsmore supplied Monroe with preliminary house plans before construction began at Oak Hill.[211]

Just as they had for the previously described houses, Montpelier's new wings made entertaining easier for the Madisons. A visitor in 1827 noted that he was among a dozen other guests.[212] Mrs. Smith recorded twenty-three visitors during her visit. She asked Mrs. Madison how she managed to accommodate them all. According to Mrs. Smith, she responded, "'Oh we have house room in plenty.' This I could easily believe, for the house seemed immense." Her respite in Dolley's chambers was brief; Mrs. Smith rejoined the guests "after adjusting our dress." Under the portico they "walked and talked until called to tea, or rather supper, for tho' tea hour, it was supper fare. The long dining table was spread, and besides tea and coffee, we had a variety of warm cakes, bread, cold meats and pastry."[213]

Inside and out, the builders and workmen refined the surfaces on the building. The interior of the wings featured finishing details such as base and surbase, architrave blocks, new door frames and jambs, windows, wainscot, window stools made of locust, molding for the door frames, two double "worked Doors with Mortise locks; 3 Single worked Do. with Common locks" and "1 Chimney Cap & Architrave." In the closets and passage they installed "47 ft rung of wash board." Exterior details also marked the Madisons' elite status. The exterior wall of the wings received a decorative cornice covered by iron sheeting, the same iron sheeting that

A Boxing Match, or Another Bloody Nose for John Bull, W. Charles, circa 1813. *Courtesy of Library of Congress, Prints and Photographs Division, Washington, D.C.*

they applied to the roof. They also installed 17 feet of sheet iron gutters. The final piece of decoration for the roof was 91 feet of "Chinese railing." Work on the upper story of the house included installing windows and finish trim, as well as Venetian blinds and a window seat.[214]

After 1811, the mansion differed from neighboring common dwellings of Orange County. Madison's selective appropriation of classical architecture, his display of French material culture and the variety of visiting politicians and foreign dignitaries distinguished Montpelier. The articulated entry space served as a gallery of art and political mementos.[215] Margaret Bayard Smith, visiting again in August 1828, noted how the central hall gave "activity to the mind, by the historic and classic ideas that it awakened." They first entered the drawing room, "which opens on the back Portico and thus commands a view through the whole house." There, she found the walls "covered with pictures, some very fine, from the ancient masters, but most of them portraits of our most distinguished men, six or eight by Stewart. The mantelpiece, tables in each corner and in fact wherever one could be fixed, were filled with busts, and groups of figures in plaster; so that this apartment had more the appearance of a museum of the arts than of a drawing room."[216] Henry D. Gilpin, a lawyer from Philadelphia on a tour of Virginia in 1827, also recalled that visitors in the central hall could sit on

A Sketch for the Regent's Speech on Mad-ass-son's Insanity, G. Cruikshank, 1812. *Courtesy of Library of Congress, Prints and Photographs Division, Washington, D.C.*

sofas on either side of the room and view "some large and good historical pictures by Flemish artists," portraits of George Washington and Thomas Jefferson, "a great number of busts," a bronze statuette of Napoleon and "some good casts of antique statues." Gilpin equated Montpelier with the President's House in Washington since "much of the furniture of the room had the appearance of Presidential splendour, such as sofas covered with crimson damask on each side, three or four large looking glasses &c–&c every thing displayed in its arrangement great order, neatness & taste—for which I fancy Mrs. Madison is remarkable."[217]

The 1815 Orange County personal property tax assessment, an 1836 inventory and a memoir document the complex assemblage of goods at Montpelier. The list included household furniture, framed engravings, mirrors, numerous tables, French china, gilt china, carpets, chairs, damask window curtains and numerous images in paintings and prints. Souvenirs, a model of the USS *Constitution* in a glass box, a live oak vase carved from its hull and busts of famous individuals stood in other rooms of the mansion.[218] A collection of the flags of twenty-nine vessels captured by the frigate USS *President* was sewn together and presented as a gift in 1815.[219] On the walls, Madison displayed engravings of the battle of Bunker Hill and other military battles and two prints of John Vanderlyn's popular paintings of

The Fall of Washington—or Maddy in Full Flight, S.W. Fores, 1814. *Courtesy of Library of Congress, Prints and Photographs Division, Washington, D.C.*

Niagara Falls.[220] Harriet Martineau recalled touring with Madison through the house: "The whole of this day was spent like the last [talking about politics and culture in the sitting room], except that we went over the house looking at the busts and prints, which gave an English air to the dwelling, otherwise wholly Virginian."[221] Madison's collection can be categorized as eclectic, with a celebratory American history theme. Furthermore, the memorabilia celebrating the victory contrasts to the cartoons disparaging Madison during the war and the destruction of the capitol.

CHAPTER SIX

The grounds were reorganized and formalized at the turn of the nineteenth century. Manipulations and alterations of the landscape from 1797 to 1811 also reveal aspects of President Madison's character and clues to the culture of early nineteenth-century Virginia elites. Refinements to President Madison's prospect as the second generation of elite Virginia planters at the site signify elevated class standing, conformity to the prevailing conventions of gentility and a willingness to adopt the landscape design trends of Europe in order to maintain class standing. The features of the Montpelier grounds composed a complex ideological statement: a selective rejection of ostentatious ornamentation and luxury along with an adoption of elite cultural forms to mark Madison's high social status.[222]

Work on Montpelier's formal garden began in Madison's first term as president. Through James Monroe, Madison secured the services of a French landscape gardener working in Piedmont Virginia named Bizet. Monroe knew of Bizet through his work in Albemarle County and, with reservations, recommended him to Madison in July 1810:

> *He is an honest hard working man, with much information in his branch of business, but his vision is too imperfect to allow him to embrace distant objects, which is of importance in certain kinds of improv'ment. Add to which, that altho his education was good, the employment hitherto given him has been calculated rather to contract than enlarge his knowledge, of the ornamental kind.*[223]

In contrast to Monroe's assessment, a Madison family relation described Bizet as "an experienced French gardener, who lived many years on the place." He came to Virginia during the French Revolution, and he returned to France shortly before Madison's death. Mary Cutts also commented on Bizet's relation with the Montpelier slaves: "They [Bizet and his wife]

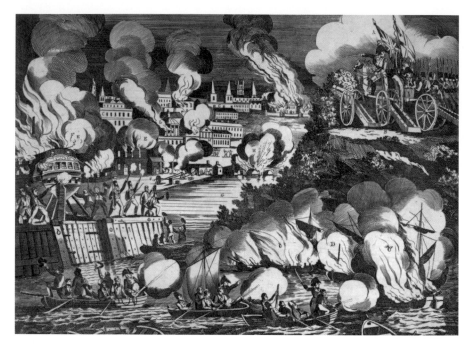

The Taking of the City of Washington in America, G. Thompson, 1814. *Courtesy of Library of Congress, Prints and Photographs Division, Washington, D.C.*

were great favorites with the negroes, some of whom they taught to speak French." One slave even had "an old worn French copy of Telemachus," which Bizet gave her.[224] Bizet and the slaves Madison assigned to him created a terraced garden close to the house. The flats were wide enough for walking alongside garden beds. The highest flat positioned the viewer for an artificially arranged, modest mountain vista. The stepped plan of the garden allowed for a comprehensive view of specimens when standing at the lowest vantage point.

In adopting the terrace design for his formal garden, Madison followed a prevailing elite convention. Many of the wealthy Virginia planters who commanded plantations along waterways had improved their grounds to enhance the available views in the eighteenth century. Some of Madison's contemporaries and fellow statesmen modified their grounds with terraces. For instance, George Mason's Gunston Hall on the Potomac River and John Robinson's Pleasant Hill on the Mattaponi River featured terraced slopes, as did John Tayloe's Mount Airy on the Rappahannock River. Also, the formal gardens of the Governor's Palace and the College of William & Mary offered Madison examples to draw from when he decided to improve his own grounds. Madison visited William Bartram's Philadelphia garden,

A View of the President's House in the City of Washington after the Conflagration of the 24ᵗʰ August 1814, G. Munger and W. Strickland, 1814. *Courtesy of Library of Congress, Prints and Photographs Division, Washington, D.C.*

which was noted for its display of botanicals. A formal garden was expected of a genteel family, in that formal gardens sustained genteel behavior and conversation.[225]

The terrace feature provided an opportunity not just to display a contrived vista, but also to display the planter's horticultural acumen in a theatrical manner. Bernard McMahon, a Philadelphia nurseryman and contemporary of Madison, described some terraces in American gardens as "considerable rising ground in theatrical arrangement." Madison was aware of McMahon's landscaping knowledge, having ordered seeds from him.[226] Along with providing garden produce for the Madisons' table, the terrace served as a conversation piece and marked Madison's membership in the upper ranks of society. The terraced garden and architectural features of the house demonstrate Madison's appreciation for composing landscape views. For instance, the view from the upper level of the garden was designed as a conventional picturesque landscape with formal plantings in the foreground and a view of mountainous wilderness in the background. The garden view complemented the western mountain vista from the portico, which Mrs. Thornton described in 1802. The roof over the wings also offered a vantage point. The creation of such a landscape distinguished Madison from the egalitarian social order emerging in the early American republic.

The French visitor in 1816, mentioned earlier, comprehended the vistas and the refined effect Madison had created since his father died. Before

The Capitol at the end of Madison's last term in office, circa 1824. *Courtesy of Library of Congress, Prints and Photographs Division, Washington, D.C.*

arriving at Montpelier, Baron de Montlezun thought that Piedmont Virginia, like the rest of the United States, lacked "an advanced society of good taste and tone enriched by urbanity." He criticized the climate, the soil, the people, their "badly formed manners, crude usages, religious fanaticism" and their "democracy, which is unbearable." His first impression of Montpelier did little to change his mind. "His home is not at all pretentious, nor in consonance with what the high position of the owner would lead one to expect. It can hardly be seen in the midst of the trees which surround it." Once inside, however, he found that the interiors were "agreeably planned and decently furnished." As for the house, it was "plain in its exterior," but the grounds, "laid out in an English garden," enhanced it. The massing of the house, he wrote, was "softened by pleasant lawns bordering on woods laid out in park-like vistas at unequal distances, which agreeably varies the perspective."[227]

During Madison's presidency, Montpelier took on the characteristics of an ornamental farm, with pleasure grounds surrounded by productive agricultural fields. The landscape, which featured a variety of improvements, bore witness for Madison's agrarian outlook. The assemblage of objects also supported his reputation as a gentleman farmer: innovative agricultural machines, new breeds of livestock and new varieties of grains. Madison also used agriculture as a means to negotiate a cultural dilemma. With the development of an egalitarian social climate and market-oriented conditions after the Revolution, traditional notions of virtue and personal sacrifice,

characteristics that the founding fathers regarded as fundamental to the life of the republic, gave way to liberal behaviors defined by self-interest and free enterprise.[228] Madison saw farming as the basis for republican ideology and the preservation of the union. Madison's efforts to improve the quality of husbandry were motivated by a desire to preserve agrarian character and benefit the financially troubled Virginia farmer. Nevertheless, from his bucolic world at Montpelier, he watched America trend toward a liberalism that bore little resemblance to the virtuous behavior models he found in classical literature. Popular licentiousness and rapacity threatened to corrupt national character, while Madison farmed.[229]

The farm, then, was rich in meaning for Madison. Baron Montlezun included a description of Madison's farm operation in the account of his visit.

> *I went today* [September 18, 1816] *to one of the farms of the President to see a wheat thrashing machine; it is composed of two parts, one of which receives the sheaves fed into it by Negroes as fast as the stripping process allows, while the other made up of large cog-wheels which turn the wooden cylinder which acts on the first machine is driven by four horses. This machine turns out two hundred bushels a day.*[230]

Madison had a longstanding interest in improvements to farm machinery. For instance, he secured a new plow model made by George Logan, a founder of the Philadelphia Society for Promoting Agriculture, in Philadelphia in 1793. It proved to be sufficient, but he sought to improve it by attaching the coulter to the point of the share. He thought that "the detached form may answer best in old clean ground; but will not stand the shocks of our rough & rooty land, especially in the hands of our ploughmen."[231] Later, he described the result of his redesign to Jefferson: "I have tried the patent plow amended by fixing the Colter in the usual way. It succeeds perfectly, and I think forms the plow best suited to its object."[232]

Productive fields included pasture for sheep, which had been part of Montpelier's livestock since the 1730s, but Madison sought to improve even the sheep by adding imported merinos to his flock. "On the same farm," wrote Montlezun, "the merinos, the large-tailed rams of the Cape of Good Hope, and their cross-bred offspring with the old stock, make up numerous flocks, the wool of which is highly prized and brings a good price."[233] In 1809, Madison made a public demonstration of his interest in promoting merinos when he wore a suit of merino wool to his inauguration ceremony.[234] He began breeding imported sheep into his flock with a merino he received from Chancellor Robert R. Livingston through George Washington Parke

Marquis de LaFayette, P.S. Duval, circa 1851. *Courtesy of Library of Congress, Prints and Photographs Division, Washington, D.C.*

Custis in 1810.[235] Livingston had sent him information on merinos in October 1809, which, Madison wrote, "afforded me much pleasure by the information it gave of the success with which you prosecuted your plan of enlightening your countrymen on the subject of sheep & wool." Madison hoped Livingston's promotions would be "duly felt in all the states adapted to those objects." In Madison's opinion, native sheep would be "greatly strengthened by the additional value given to their fleeces by the merino blood." By improving the quality of American sheep, Madison anticipated, what he termed, "a valuable revolution" in American agriculture.[236]

As he was producing his own merino cross-breeds, Madison used not just his farm as a model, but his presidential office to further the cause of agricultural reform and diversify sources of agricultural profit. Writing to Jefferson, Madison declared that the "general idea of disposing of the supernumerary Merino Rams for the public benefit had occurred to me."[237] To achieve that goal, Madison requested that John Armstrong secure permission from the French to import merinos in 1809, arguing that "the value of this breed to our Country is now generally understood, and acquisitions of specimens are acceptable services to the public."[238] William Jarvis, American consul in Lisbon, Portugal, sent the sheep to Alexandria, Virginia, in 1810. After Madison tended to infections on the sheep that had developed during shipment, his overseer brought some of them to Montpelier. He sent two to Monticello for Jefferson and Captain Isaac Coles in May 1810.[239] Madison shipped some of the merinos beyond Virginia. Two of the large tail variety "I have disposed of here, one of them to Claiborne, for the benefit of the Orleans meat Market." Madison

augmented the shipment of rams with ewes: "I send home also, by this oppy. six Merino Ewes, which had been destined for Hooe of Alexanda. Finding that the arrangements necessary for the original pair, would provide for small flock, I have been tempted to make this addition to them; as a fund of pure Merino blood, worth attending to."[240]

Madison thanked Jarvis for facilitating this agricultural improvement program in June 1810. In this letter, he reiterated his intention for "this precious breed of sheep" to serve the public good. He also noted that the effects of this improvement appeared to be evident in the rising price of merinos. He wrote, "I propose in the disposition of the Ram lambs of full blood to study as the sole object, a propagation [of] the breed for the public good. Mr. Jefferson has the same purpose."[241] Purchases of more foreign sheep at auctions in Baltimore, Richmond and Alexandria in 1810 and 1811 reflected Madison's commitment to merino interbreeding.[242]

Public interest in Montpelier's flock of merino sheep grew. For instance, Hay Battaile, passing Montpelier on his way to the White Sulphur Springs in 1811, "call'd on Mr Gooch…to get a pair or a Ram of your broad Tail sheep." Gooch denied Battaile's request, but he thought he might have a second opportunity of getting some of Madison's sheep since he knew, through Mr. Gooch, that Madison would be "geting a stock of two other breeds, that you liked much better."[243] In addition, Thomas Jefferson informed a correspondent in 1813 that Madison had merino sheep and sold young ram lambs.[244]

Madison described the state of his flock to Richard Peters in March 1811. He wrote, "I have had broad tails, 4 or 5 years on my farm, which agree in all the distinctive merits of yours, except that their wool is more coarse. I have lately recd. from Algiers several Rams of that breed, remarkable for the size of their tails; but with fleeces all coarse, tho' not equally so; but all useful for the loom." He also described to Peters his sheep diffusion program: "I have distributed them into different hands & situations, with a view to preserve the stock."[245] Based on Madison's description, Peters surmised, "Your Sheep I think must be the Barbary Coast Sheep. They are of the same Race, but not so good as the Mountain Sheep."[246]

Peters's judgment had a profound effect upon Madison. He attempted to acquire the mountain breed in October 1811. Additions to the flock were needed because the lamb was killed accidentally before it reached Montpelier, and the four-horned ram died soon thereafter. Left with only an old ram, Madison prevailed upon the American consul general in North Africa Tobias Lear to secure and ship a pair, "or if readily to be done, more than one pair of those animals."[247] Based upon Peters's information, Madison insisted on having the mountain breed and gave Lear instructions

on where to find them. "Perhaps," he wrote, "there may be broad-tailed families in Algiers, cloathed with fine fleeces; finer even than those of our ordinary sheep." He instructed Lear to search in Tunis, "towards the Mountains at least, there are broad-tailed sheep with fleeces considerably finer than our common wool." Madison had seen samples of Tunisian sheep, he told Lear, "from a flock of Judge Peters, who sent them to me, with a sample of Cloth made of the material, & with an Eulogium on the longevity, the mutton, & other merits of the Sheep." He also mentioned that "southward of Tripoli, there is a broad-tail sheep, equally remarkable for the succulence of the meat, & a fineness of wool, almost rivalling that of the Merino."[248] Madison's request to Lear indicated his private and public interest in these sheep.

By raising and interbreeding merinos, or Barbary sheep, Madison meant to preserve agrarian virtue in society by expanding market opportunities for farmers. Likewise, Peters recognized the social and economic dimensions and associated sheep raising with republicanism. In Peters's letter to Madison, he told him, "Being a good Republican, I have a Coat made for my own wearing. I could not get it dyed in the Wool, without more Trouble than I chose to take, or I would have had it black; & would have worn it for my Costume. It would have then been on a Par with my Office; which is happily situated—below Envy & above Contempt. You see I am…neither ambitious nor vulgar."[249] For Tench Coxe, raising merinos was a patriotic act. He wrote to Madison that "if such a course [war] shall be taken towards us, manufactures must support our Agriculture, and the woolen manufacture, with some aid from the cotton, must become necessary to effective war."[250] Madison agreed with Livingston's plan of improvement, Peters's argument and Coxe's assertion that homespun merino garments comported with the republican aversion to luxury and advocacy of domestic manufactures. The changes to Montpelier's flocks demonstrated his agreement.

The tasks associated with sheep, tending, shearing and spinning of wool at home, fell to the slaves on the various quarters. Montlezun noted that the Montpelier slaves "are divided among the numerous farms which constitute his holdings. Some of these farmhouses are very pretty, built of wood, clean, and comfortable." The presence of slaves at Montpelier provided a tincture of colonial domination familiar to Montlezun. He wrote, "Sometimes I imagine that I am still in a settlement of one of our colonies." Agricultural stoop work and domestic service "is done here by Negroes and people of color as in the Antilles."[251] Montlezun stated that the slaves were treated well, but we can gauge Madison's management of and attitude toward his slaves as he expressed them in instructions to his overseers in 1790. The overseer's duties, according to Madison, were "to chuse out one of the Milch Cows for

his own use, and let the rest be milked for the Negroes. To keep the Negroes supplied with meal to be kept in a barrell apart for themselves…To treat the Negroes with all the humanity & kindness consistent with their necessary subordination and work."[252]

By his own admission, Madison also used threats to maintain his control of slaves. For instance, he wrote to his father that he had to discipline a slave named John, due to "his misbehaviour in Fredericksbg." Madison told his father that John's disobedience, which was not described, "was followed by some serious reprehensions, & threats from me, which have never lost their effect."[253] From another point of view, Madison was remembered as a benevolent master. For instance, Paul Jennings, a former Montpelier slave, recalled that while he was in Madison's service, he never saw Madison strike a slave. "Whenever any slaves were reported to him as stealing or 'cutting up' badly, he would send for them and admonish them privately, and never mortify them by doing it before others. They generally served him faithfully. He was temperate in his habits."[254]

The subordination and work of the slaves provided the base for Madison's elevated social standing and his reputation as an experimental farmer. His farming interests are reflected in exchanges of seeds. He offered his neighbors new varieties of grains that were given to him. In 1793, he sent James Monroe an ear of corn, which he claimed "is forwarder by three weeks than the ordinary sort; and if given to your overseer may supply a seasonable dish on your return next summer."[255] From Philadelphia, Madison sent samples of "wheat from Buenos Ayres and of Barley from Old Spain" to Charles P. Howard, a neighboring farmer located in Orange County. Although he could not guarantee any improvement in the quality of the grain, "such experiments are at least curious, and multiply the chances of discovery."[256]

Recognition of Madison's efforts in agricultural improvement came in the early 1800s. Thomas Moore praised his farming, sought his opinion and certified him as a model farmer: "Thy character as a person of general information, & more especially as a successful practical farmer, induces me to believe that thou art very competent to judge of the merits of the work."[257] Moore later sent a certificate from a Montgomery County, Maryland farmers' society, which praised Madison for "his zeal to promote Agricultural knowledge."[258] Madison thanked them for such a "testimony of respect." He also expressed his belief in the fundamental importance of agriculture: "The art which draws from the earth the subsistence of mankind, is not only the most important in itself, but the basis of all other arts."[259] James Monroe also complimented him for his agricultural (and architectural) knowledge in 1799: "Your skill in architecture and farming

wo'd be of great use to me at present. I am engaged in both and take more interest, especially in the latter. tho' under discouraging circumstances, than at any former time."[260]

Madison's statements on agriculture as a foundation for virtue in the republic were well known. His agrarian ideology can be traced to classical sources as well as the social and economic experience of growing up on a farm. His father's library included an agricultural treatise. Moreover, having read *The Politics*, Madison learned from Aristotle the value of an agrarian population base in a republican form of government. Aristotle shrewdly noted that a republic was more likely to succeed if its citizens were perpetually busy in the fields far from cities and the centers of government. Thus, farmers would be less susceptible to the rhetoric of demagogues and less likely to support political intrigues that tempted their wage-earning counterpart in the city.[261] In an essay entitled "Republican Distribution of Citizens," Madison praised farm life in terms that paralleled Aristotle's, writing that the life of a farmer "is pre-eminently suited to the comfort and happiness of the individual…the class of citizens who provide at once their own food and their own raiment, may be viewed as the most truly independent and happy. They are more; they are the best basis of public liberty and the strongest bulwark of public safety."[262] Jefferson shared this agrarian outlook. In a letter to Madison, he predicted, "Our governments will remain virtuous for many centuries as long as they are chiefly agricultural."[263] Madison addressed members of Congress on this subject. "In my opinion," he said, "it would be proper also, for gentlemen to consider the means of encouraging the great staple of America, I mean agriculture, which I think may justly be styled the staple of the United States; from the spontaneous productions which nature furnished, and the manifest preference it has over every other object of emolument in this country."[264]

After his second term as president, Madison continued his efforts at agricultural improvement through a local society of gentlemen farmers. This activity was not unique to Piedmont Virginia. The formation of local societies for improving farm productivity emerged as a trend in the late eighteenth and early nineteenth centuries. Particularly after the Revolution, the leading farmers from various regions of the United States organized into agricultural societies to promote improved farming as well as their own reputations. Although George Washington had proposed federal support for agricultural improvement, no appropriations from Congress were forthcoming.[265] Therefore, the effort was largely local in nature. In spite of the local organization of these societies, common yeomen were rarely included in the membership. For instance, the Massachusetts Society for the

Promotion of Agriculture members rarely published papers on experimental agriculture practices. Instead, they shared gardening tips among themselves and only occasionally offered premiums at fairs. Elite Bostonians promoted agriculture as a countermeasure against the growing spirit of commerce, the erosion of their social prominence and the corruption embedded in luxury.[266] Similarly, the South Carolina Agricultural Society membership included elite politicians and the wealthy slaveholders who, some have argued, used agricultural improvement advocacy only to maintain unequal social relations by denying lower social classes access to slaves, land and improved agricultural knowledge. The results of their experiments with agricultural commodities were restricted to members.[267] Both societies demonstrated more concern with mitigating the liberalizing spirit of modernity and the decline in elite privilege than with immediate reforms to common husbandry.

The Agricultural Society of Albemarle, where Madison held a membership, consisted of local elites, politicians and slaveholders who sought to maintain rural domestic economy and prosperity as a base for republican character.[268] Additionally, the society existed as armature for the display of the local gentry's agricultural acumen and largess. It supported their identity as cultivated gentleman farmers and their standing as Piedmont grandees. Yet Madison believed this "patriotic society" (his term) would provide "its full quota of information…to the general stock."[269] It did fulfill this promise when it published his 1818 address in the *American Farmer*.

His address covered various aspects of the state of agriculture in Virginia. It featured comments on soil exhaustion, livestock, pasturage and the application of manures. He advocated deep plowing, "cultivation in horizontal drills" and intensive fertilization as remedies. "The neglect of manures is another error which claims particular notice," Madison told his audience. His recommendation: "applying to the soil a sufficiency of animal and vegetable matter in a putrefied state, or a state ready for putrefaction." He recommended plowing with oxen rather than horses. Timothy and clover hays received his recommendation as animal fodder since they would provide "stable manure for gardens and culinary crops." He added plaster of gypsum, lime and marl to his list of recommended fertilizer applications.[270]

Madison employed ancient agricultural tracts and allegories to inform his thinking and amplify his arguments for progressive farming. He cited Pliny and Varro to bolster his own prescriptive privilege, references that carried little meaning for common yeomen. He invoked Columella, an ancient Roman authority on agriculture, to convey the benefits of fertilization and to underscore the moral dimension of improved farming. "One of

the Roman writers on husbandry enforces the obligation to an improving management," he said. He then retold Columella's story of Paridius successfully dividing his vineyard among his daughters upon their marriage without suffering any loss of productivity to his remaining portions because he fertilized. "The story, short as it is," said Madison, "contains a volume of instruction."[271] Elsewhere, Madison had described James Monroe as "a worshipper of Ceres" when he learned Monroe was growing corn.[272]

Madison's classical references demonstrate his reliance on antiquity to illustrate his thoughts. They show the continuing relevance of classical literature among elites in the early national period.[273] However, Federalists who took note of Southern agricultural societies ridiculed them for presuming that they might better manage their farms by reading classical pastoral literature and advocating self-sufficient farming and home manufactures while wearing suits of imported cloth.[274]

In Madison's lifetime soil chemistry was a speculative and elitist endeavor, but he included it in his address nonetheless. Based on their understanding of elements, Madison claimed, "The chemist, though as yet a fellow student as much as a preceptor of the agriculturalist, justly claims attention to the result of his processes."[275] A group of upstate New York gentlemen farmers, similar to the social standing of the Agricultural Society of Albemarle members, organized a New York State agricultural society in 1832 to pursue solutions to soil exhaustion problems. Their early attempts to understand soil chemistry generated competing theories of fertilizers as atmospheric or soil-based. Furthermore, their recommendations were met with skepticism by local farmers. Only after Americans began studying in Germany with the chemist Justus von Liebig did soil analysis gain respect in the United States in the last half of the nineteenth century. Prior to that, European travelers studied North American natural resources with greater authority than did United States citizens. Madison's reference to soil chemistry reflects an elite interest in the formative stages of this field of inquiry.[276] Historians credit Virginia's agricultural reformers, particularly Madison, Jefferson, Edmund Ruffin and John Taylor of Caroline, for diversifying agricultural practices. However, the improvements were limited to large plantations with numerous slaves. In Orange County, agricultural reform and crop diversification were underway before the agricultural societies organized, and they were geared toward the needs of large slave plantations and social activities.[277]

All of the features of Montpelier, including the house and grounds, had been set in order by Madison as a way to meet the prevailing standard to govern, a standard he had put forth in *The Federalist* essays. As the product of a republican outlook and a long tradition of plantation slavery, Montpelier set Madison apart from commercial men, whom he described on one occasion

as "men of factious tempters, of local prejudices, or of sinister designs, [who] may, by intrigue, by corruption, or by other means, first obtain the suffrages, and then betray the interests of the people." Montpelier enabled Madison to count himself among the governing class, men "whose wisdom may best discern the true interest of their country and whose patriotism and love of justice will be least likely to sacrifice it to temporary or partial considerations." These were the "requisite endowments" that Madison defined in *The Federalist* essays as necessary to represent constituents and hold civil authority. His mode of living and building at Montpelier placed him in the class "whose enlightened views and virtuous sentiments render them superior to local prejudices, and to schemes of injustice." His activities at Montpelier reflect his standing among the class of men who, in his words, possess the "most wisdom to discern, and most virtue to pursue, the common good of society."[278]

Madison's role in the agricultural society and the appearance of his farmland indicates his faith in the regenerative capacity of the North American landscape. That same faith in the North American landscape as a foundation for the new republic's beginning supported the revolutionary generation. Leo Marx argues that in the late eighteenth century the landscape had revolutionary force and symbolic significance, capable of serving as "an explanation of the formation of the national character." With its timelessness, continental expansiveness and fecundity, the landscape seemed capable of supporting prosperity and the individual's pursuit of happiness. Madison's activities at Montpelier exemplified the republican concept of political economy. His interest in farm reform was an attempt to arrest the fugitive spirit of virtuous agrarianism in a republic that was embracing liberalism and trending toward corruption through rapacity. Improved farming could secure a middle ground and keep the United States in a youthful state, as opposed to the overdeveloped condition of Europe. Leo Marx defines such a conception of the middle landscape as that symbolic space "created by the mediation between art and nature." In a nation with an undefined landscape tradition and a vast domain of underdeveloped territory, it seemed possible from the vantage point of Montpelier to hold a course between the savage state and the urban, industrial debauchery of Europe. The promise they perceived in the landscape, however, excluded Native Americans and African Americans and was, in the end, illusory.[279]

The agrarian legacy that Madison had instilled into the house and grounds at Montpelier could not endure. Montpelier's acreage began to decrease in Madison's retirement. He sold and mortgaged portions of his plantation to cover various indebtedness of his own and others. For instance, Madison mortgaged 361 acres to Charles Scott and Francis Cowherd on October 12, 1825, in order to secure a $1,000 debt of his own and $1,000 on account of

his ward, Lucy W. Daniel. Later, he sold 120 acres to Reuben Newman for $1,370. He mortgaged the 800-acre Black Meadow farm to secure a $3,000 debt owed to Francis Cowherd.[280] Sales of slaves attended his sales of land in the 1830s.[281] Some of the transactions protected his son-in-law, John Payne Todd, from creditors who briefly had imprisoned him in Baltimore. The size of Montpelier's slave community, which had peaked in 1801 at 108, diminished to 63 in 1828. Madison paid taxes on 61 slaves in 1830, 1831 and 1832. In the 1835 assessment, though, Madison's taxable slave population dramatically dropped to 40 members as a result of his sales to a neighbor in 1834.[282] It fell again to 38 in 1836.[283] Madison explained the circumstances of his sale of slaves to a famous visitor, Harriet Martineau, at this time in the plantation's history. She noted that "he accounted for his selling his slaves by mentioning their horror of going to Liberia, a horror which he admitted to be prevalent among the blacks."[284]

Madison's confinement of his slave community in perpetual bondage contrasted sharply to that of his neighbor and friend, Edward Coles of Albemarle County. Coles, who had served for a time as President Madison's private secretary in Washington, chided Madison about the condition of slaves in the United States when together they passed a slave auction in progress in Washington, D.C. Later, Coles toured Europe after completing a diplomatic mission to Russia, but instead of returning to farm his ancestral slave plantation in Albemarle County, he emancipated all of his slaves in Illinois in 1819. He wrote to Madison to tell him of the slaves' emancipation. Madison replied with guarded congratulations and notified him of the sale of his own slaves:

> *Finding that I have, in order to avoid the sale of Negroes sold land until the residue will not support them, concentered and increasing as they are, I have yielded to the necessity of parting with some of them to a friend and kinsman* [W. Taylor], *who I am persuaded will do better by them than I can, and to whom they gladly consent to be transferred. By this transaction I am enabled to replace the sum you kindly loaned me.*[285]

The decline of Montpelier was apparent to Charles J. Ingersoll, who visited Montpelier one month before Madison died on June 26, 1836. He described the house as "decayed and in need of inconsiderable repairs which, at a trifling expense, would make a great difference in favor of the first impression of his residence." Ingersoll identified slavery as the cause of Montpelier's misfortune. Ingersoll surmised that the cost of supporting the slave community prohibited maintenance of the estate. He found that nearly two-thirds of

his slaves are too young or too old to work too much, while the support of so many is very expensive. It takes nearly all he makes to feed, clothe, and preserve them; and when a handsome column or other ornamental part of his mansion falls into decay, he wants the means of conveniently repairing it, without encroaching on necessary expenditures—besides the difficulty of getting adequate artists at such a distance from their common resorts.

Ingersoll wrote that Madison "spoke often and anxiously of slave property as the worst possible for profit." He added that Madison admitted the deficiencies of slave labor in agriculture. "When I mentioned Mr. Rush's productive farm of ten acres, near Philadelphia, he said he had no doubt it was more profitable than his with two thousand."[286]

The condition of Montpelier in 1836 indicated the consequences of Madison's entrenched attitude toward slavery and the failure of colonization as a path to emancipation. Nevertheless, Madison's faith in emancipation through colonization was unshaken. His will included his mill as a bequest to the American Colonization Society after the death of his wife Dolley in hopes of furthering their cause. Although she tried for eight years to manage the plantation, Montpelier, as his legacy, became her unbearable burden.[287]

CHAPTER SEVEN

A month after her husband's death, Dolley Madison's grief had not abated. She wrote to her sister, "Indeed I have been as one in a troubled dream since my irreparable loss of him."[288] Mrs. Septima Anne Cary Randolph Meikleham recalled a visit to Montpelier after 1836. She wrote, "The change was most sad. The house seemed utterly deserted. The great Statesman, loving husband, kind Master, and attentive friend was gone. And we three seemed lost in the great desolate house." Even with the company of her niece Anna Payne, Dolley appeared "broken hearted" to Mrs. Meikleham.[289]

Visitors continued to come to Montpelier. Most were family members. Dolley spent the winter of 1839–40 at home entertaining family. She wrote to her sister, "Our winter set in a month earlier than usual and before two marriages in our family, of great nieces and nephews could be consummated I was literally weather bound—they would not allow me to leave home before I had given them frolicke and partaken of others."[290] There was only one documented instance of a visitor, who thought of Montpelier as a shrine, coming to pay respects. Anthony Morris wrote to her in 1837. "Among the reviving powers of spring which I pray may shed its choicest blessing on Mont Pelier, its influence here is to renew the hope to my dear Mary and myself of making our so long intended visit to its Shrine which without even waiting for your concurrence as to time, we propose to do on the first fair day Thursday."[291] Another visitor in 1839 noted twenty guests at Montpelier prior to his arrival.[292] Although the social round at Montpelier continued, honoring Madison's memory was not a pronounced component of the visits. Those who did visit were either relatives coming to see Mrs. Madison or close acquaintances stopping by on their travels through the area.

Under Dolley P. Madison, the number of slaves at Montpelier increased. Starting with 44 taxable slaves in 1837, she commanded 52 by 1841. The

Dolley Payne Madison, Mathew B. Brady, circa 1848. *Courtesy of Brady-Handy Collection, Library of Congress, Prints and Photographs Division, Washington, D.C.*

1840 census enumerated 103 slaves and 7 free whites at Montpelier. By contrast, the 1830 census enumerated 97 slaves and 3 free white people. In 1840, 33 slaves were employed in agriculture; 3 slaves worked in manufactures and trades. The 1842 tax assessment showed 1 white male (presumably the overseer), 7 slaves over twelve years old and 36 over sixteen years.[293]

Typically, historians associate Dolley Madison with hospitality, but her writings during that time reveal her management of Montpelier's slaves and agricultural production. In her memoir, Margaret Bayard Smith recorded an 1838 letter from Dolley that characterized the daily round at Montpelier after the death of President Madison. Dolley wrote that she was "involved in a variety of business—reading, writing, and flying about the house, garden, and grove—straining my eyes to the height of my spirits, until they became inflamed, and frightened into idleness and to quietly sitting in drawing-room with my kind connexions and neighbours—sometimes talking like the *farmeress*, and often acting the Character from my rocking chair."[294] Dolley also supervised tobacco shipments. She wrote to her agent in 1840, "We now send you the last hogshead of Tobacco from the last crop with thanks for all your kind attention." From this same agent she requested "500 wgt of Bacon of good character for black people (by return car) to be paid for by the proceeds."[295] She received tobacco seeds from a friend in New York in 1842.[296]

Fragments of letters from unidentified correspondents among her papers described the slaves' situation under new overseers. An unidentified writer,

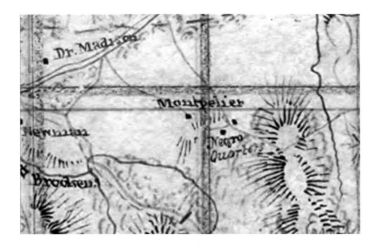

Preliminary Map of Orange County, Virginia, 1871, by Jedediah Hotchkiss. Courtesy of Hotchkiss Map Collection, Library of Congress, Geography and Maps Division, Washington, D.C.

presumably Dolley, stated, "As to overseers, I'm glad you refused the 2 first Burnley and Shackleford—no whipper of negroes should ever have our people or any others." However, she admitted that an overseer "must be employed because they will not work without, but let it be a good & feeling honest one without much or any family…then they want less provision." The writer also stated, "I am out of all provisions." She also commented on "the exertion of servants in the orchard—lazy women."[297]

Changes in the slave community included the transfer of labor to another quarter and to a quarry. Dolley's son, John Payne Todd, expanded the extraction of natural resources at Montpelier by opening a marble quarry, named the Montpelier Marble Quarry, located on Madison Run.[298] Earlier, Dolley noted her son's attention to the quarry and its product. In 1833, she wrote, "Payne is at home and improving his knowledge of geology."[299] Later, she told her doctor in 1841, "My son is now on a visit to his marble quarry."[300] She also described a trip Todd made to Richmond to sell "some specimens of fine marble."[301] Among the papers of Dolley was a note that bore on Todd's marble business: "A lady came to me the other day to buy the marble steps… she would give what the market of the public [would] decide they were worth. I told her have them valued and let me know."[302] Some of Montpelier's slaves were shifted from field work to the quarry. The 1840 census identified nine Montpelier slaves employed in mining—presumably at Todd's quarry.[303]

In 1837, Todd established a farm called Toddsberth that was separate from Montpelier but was worked by slaves from there. The house stood on nine and a half acres in Orange County. In 1839, the building was valued at $84.22. After improvements, the assessment increased to $786 in 1840.[304] According to an 1846 deed, numerous slaves, one of them skilled, lived and worked there:

A Negro Man named John (Blacksmith), a Negro Man named Matthew, about forty five years old, a Negro Woman named Winny (wife of the Said Man Matthew,) a Negro man named Willoughby, about Sixty years old, A Negro man named Gabriel about fifty years old, a Negro Man named Beny five years old, a negro boy named Abraham about Eighteen years old, a Negro girl named Violett.[305]

This group of slaves was part of a larger selection of slaves Dolley had deeded to her son in 1844.[306]

Todd planned to move his mother to Toddsberth. According to Lucia Beverly Cutts (a descendant of Dolley's sister Anna Payne Cutts), Todd spent "much money in carrying out his eccentric ideas for her comfort." He built a cluster of small cottages "around a tower-like building, containing the ball-room and dining-room." One of these cottages was intended "for his mother, which, in order to obviate the fatigue of a staircase, she was to enter from the dining-room by a window," according to Cutts. Most of Montpelier's "precious souvenirs were removed" to Toddsberth.[307] Household furniture, taken from Montpelier, included "two feather beds, Steads & furniture, two large mirrors, half dozen chairs, one dining table."[308] A selection of decorative items listed in the inventory of Todd's estate after his death in 1852 included "Sketch by Rubens of Maxn.; Misstress of Titian; Bacchus, Dicul des Laisons; a Bas relief; vue de campo Vaccino; a looking glass with the ornaments a round of little Room at Montpelier; two large tumblers; two decanters Pittsburg & 3 Stoppers; 1. Cut glass Presem or Sugar dish."[309]

By the time of the Civil War, Toddsberth had gained a reputation as a folly. A detachment of soldiers camping in the Madison Run Station area noticed it in a state of ruin. One of them, J.H. Chamberlayne, recorded his observations for his relatives back home:

Our camp here is in a pleasant place, where Payne Todd lived of whom Mother knows, he spent all the property Mr. Madison owned & most that Mrs. Madison got from the Government. The marks of the poor spendthrift are still to be seen, walks that he began, never to finish, an attempted ice house turned into a stately pleasure dome, like Kubla Kahn's; quarries opened for marble which was not there.[310]

Even with the changes initiated by her son's projects, Dolley's stewardship of Montpelier was noted by one visitor as a success. In 1839, J. Bayard H. Smith contrasted his experience at Montpelier to the dilapidated state he witnessed at Monticello. At Monticello,

Madison Monument, 1858. *Courtesy of Library of Congress, Prints and Photographs Division, Washington, D.C.*

I beheld nothing but ruin and change, rotting terraces, broken cabins, the lawn ploughed up and cattle wandering among Italian mouldering vases…It was with difficulty I could restrain my tears, and I could not but exclaim, what is human greatness. At Montpelier and Mount Vernon no such feelings obtruded themselves. All wore the appearance of plenty and no change or misfortune had overwhelmed them.[311]

For Smith, the legacy of the founding fathers was visible in the preservation of their buildings, and he credited Dolley for preserving President Madison's memory at Montpelier. Additionally, Dolley had also preserved more personal relics of her husband. For instance, the day after he died, she cut a lock of hair from his corpse and mailed it off. A brief note accompanied the long, large cutting of hair: "For Eliza Lee, from D.P.M. James Madison's hair. June 28th. 1836."[312] Her stewardship of Madison's legacy also included the publication of his notes from the Constitutional Convention, which were published by Congress through her efforts.[313]

Dolley's dedication to Montpelier, however, was a burden she could not bear for long. "In truth," she wrote to Margaret Bayard Smith in 1838, "I am dissatisfied with the location of Montpellier, from which I can never separate myself entirely, when I think how happy I should be if it joined Washington, where I could see you always, and my valued acquaintance also of that city."[314] From 1837 to 1839, she spent her winters at her Washington townhouse, which was built by her brother-in-law Richard Cutts at President's [Lafayette's] Square on a town lot that President

Madison had purchased.[315] During the first three years after her husband's death, she returned to Montpelier for the summers. However, she did not travel to Washington for the winter of 1839–40. Instead, she remained at Montpelier to supervise the farm firsthand for two years, returning to Washington for the winter of 1841–42. After attempting to make the farm turn a profit again, she returned to Washington in order to sell her husband's other writings. Dolley never lived at Toddsberth. Instead, she moved back to her D.C. townhouse with her own selection of Montpelier's furnishings and slaves.[316]

Dolley's decision to leave Montpelier was motivated by the diminishing returns from the plantation and her advancing age. The personal problems of her son John Payne Todd also contributed to the decline of the farm. According to Lucia Cutts, Dolley's "extravagant, idle son" managed the farms in such a manner that "for some time [he] brought in no returns." Cutts declared that John Payne Todd's profligacy "obliged her to sell the dearly-loved Montpelier, together with the slaves, to Mr. Moncure, of Richmond."[317] In the concurring opinion of Mrs. Meikleham, Todd "had run through the fortune her [Mrs. Madison's] husband left her, $100,000 and Montpelier."[318] Katharine Anthony also places much of the blame on Todd for Dolley's financial problems. Anthony argues that Dolley resolved to sell Montpelier when she realized Todd was unfit to manage it.[319]

Dolley's release of the plantation, however, went in stages. She sold separate tracts to Henry Wood Moncure beginning in late 1842. The first land purchase was Sawney's Quarter.[320] Through a second deed Moncure secured 750 acres more, leaving him in possession of the mountain land around the headwaters of two streams southeast of the mansion house: Mill Run and Poplar Run.[321] Moncure's first appearance in the 1843 Orange County personal property tax list and land tax book showed an assessment for three slaves over twelve years of age and eight slaves over sixteen years old, plus four horses.[322] Although she no longer owned these tracts of land, Dolley was still involved in managing them.

From Richmond, Moncure relied on Dolley to convey instructions to his overseer contained in correspondence to Dolley and her niece Anna Payne, a daughter of Dolley's brother John. He prevailed upon them to relay his instructions to Mr. Chewning, the overseer. He wrote, "May I trespass on your attentions so far as to say to Mr. Chewning to employ the ditchers as quickly as he can, and on the best terms he can, for I have not time to look up workmen in this quarter." He also told Ms. Payne to tell Chewning to inspect two slave boys offered for sale by Todd, "and ask him if he can make use of them as plough boys or otherwise of service to him in his farming operations." Oddly, although the Madisons still lived there, Montpelier

was in the hands of an absentee plantation master. For instance, Moncure sent, via railroad from Richmond, servant shoes, plaster, clover seed, iron, steel, Irish potatoes for seed, bacon "and a variety of other matters for the convenience of himself [Chewning] & servants."[323]

Even though he placed demands on the Madisons, Moncure claimed his only wish was to accommodate Dolley and her niece. In his December 1842 negotiations for the first 750-acre tract of land, he declared he would "enter into no engagement which does not meet with your [Dolley's] entire approbation." In addition, he promised "to deport myself as satisfactorily and understandingly to close this negotiation which I fear has heretofore been distasteful to you."[324] He imagined the Moncure and Madison families as "neighbors full near to see each other often, which would always give me pleasure to reciprocate the politeness of my sweet little daughter & her good aunt."[325]

After the purchase of the land, Moncure announced that he was determined and happy to do anything "that will ensure the pleasure, welfare, or happiness of Mrs. Madison." However, he was quick to distinguish his property from theirs, particularly regarding the storage and division of corn, which he insisted Chewning should weigh. "You learn from this my kind Miss Anna, the difference between *mine* & *yours* accustomed as I am to the dispositions in a city to plunder, I cannot but feel, tis or will, to keep temptation out of the way."[326]

Later, Moncure realized he may have overstepped the bounds of probity with his reliance on them to provide his directions to the overseer. When he discovered that Mrs. Madison had been ill, he apologized for submitting the list of tasks for her to complete. "I write Miss Anna to beg you to give yourself no trouble about the subject matter of my last communication which I would not have requested you to observe had I known of the delicate engagements in which you have been situated," he wrote. Yet he was not so contrite as to refrain from submitting another request to Ms. Payne. He added, "May I trouble you to [convey] word to Mr. Chewning that I shall be glad to have a long letter from him giving a full account of himself the Servants and his progress. I feel anxious to learn how the oats & corn [promise] & whether he has completed his planting and about what part of the field he finished." Moncure's absentee landlord situation created other annoyances for the Madisons. For instance, Moncure had to apologize for the negligence of his overseer. "I was deeply concerned to hear he [Chewning] had let his Horses trespass on Mrs. Madison's Lawn. I hope he will early be underway erecting suitable House for himself, & all his appurtenances, on his own Place and be no more offensive to his indulgent neighbour."[327]

To compensate for the intrusions, Moncure performed small favors for the Madisons. For instance, he shipped bacon to them: "I have to day purchased about 800 lbs. and sent it to the depot in a Box directed to Mrs. Madison and by the Time this reaches you, the Bacon will be found at the Depot." In February 1843, he purchased a lot in a Richmond school fund lottery in the Madison name. He presented them the certificate and enclosed sheer silks for Ms. Payne.[328] His constant emphasis on his desire to do anything and everything to please Mrs. Madison led him to fantasize about traveling to "China, what pretties I could bring back for my <u>Prodigious</u> favourites and thereby become a favourite myself."[329] Moncure's presumed familiarity led him to call Ms. Payne his daughter. He wrote, "Ask Mrs. Madison to Laugh & make merry at what you term your impudence to me in your Letter as such as she can enjoy, for I do assure you & her good self, tis all very pleasant to me and I take pleasure to be of service to either my <u>modest Daughter</u> or my Friend Mrs. Madison."[330]

Moncure's charitable behavior with the women continued until he owned the entire plantation. After the initial land transfer, he admitted, "I wish indeed to win the pleasure of Mrs. Madison and her Son to make some arrangement to give me possession of the improvements for I feel satisfied I could render the change very acceptable to her and am very sure would secure her permanent interest thereby."[331] In June 1843, he shipped plantation supplies and favors and, as before, he prevailed upon Ms. Payne to relay the message to Chewning: "The freight train leaves for Gordonsville on Monday morning the 19th and will arrive there by 4 or 5 o'clock. Mr. Chewning will have to run his Waggon there for Sundries sent him." As usual, Moncure included presents: "I have taken the liberty to forward a box containing a few remembrances intended for your good aunt and interesting self, which I pray you both to accept. The box is marked Mrs. Madison, instruct Mr. Chewning to enquire for it when he [goes] for his own things."[332]

Moncure's relation with Todd was not as friendly. He wrote that "the Colo gave me so little opportunity to converse with him, for we might in a few minutes conversation understand each other perfectly as to our views and at once put to not all further reference to the subjects."[333] In March 1843, Moncure wrote to Ms. Payne to inform her that Todd made a "momentary call" at his Richmond office, but he "gave me no opportunity to converse with him of learning anything in relation to your good Aunt's wishes, he declined to give me the pleasure of his company to dinner." Todd's irregular conduct included a suspicious offer of Montpelier slaves for sale to Moncure: "He asked if I would purchase two boys 15 or 16 years of age named Paul & George and requested if I would do so, to plais [*sic*] the amount to Mrs. Madison's credit and receive of her a bill of sale,

I made no reply farther than to ask if they were large enough to plough and were healthy."[334] In January 1844, Todd promised his mother, "I will tell you of Moncure's conduct when I come."[335] When Moncure appeared at Montpelier in April 1844 to continue negotiations with Todd for the sale of the residue of Montpelier, his persistence was noted. Todd wrote to his mother in Washington that "Mr. Moncure has been coming every day for some time."[336] By the end of April, Moncure traveled to Baltimore, and Todd, who was suspicious of Moncure, warned her that he "is passing to Baltimore now and be cautious how you let on, I wished the advantage of spreading out the terms for your private [disposal] to me before final compromitment and your anxiety may give him an advantage in knowledge of necessities to tamper with."[337]

Dolley Madison relinquished the remaining parts of Montpelier to Moncure in August 1844.[338] By then, she was living in her Washington townhouse again and trying to sell the remainder of her husband's papers to Congress. The demands of creditors and a suit against her by her brother-in-law William Madison, who claimed an unpaid debt related to the settlement of Colonel James Madison's estate in 1801, also influenced her decision to sell Montpelier.[339] Moncure then owned "the Montpelier dwelling house, overseers house and a Mill and pond—containing one thousand and seventeen acres."[340]

Most likely the mansion house was not suitable for living at the time the Moncures purchased it. Todd had removed whatever was left after his mother freighted her goods to Washington. Dolley had given Todd all the books and pamphlets in the library as well as all of the household furniture.[341] Todd wrote to her in January 1844, "I am collecting for Toddsberth."[342] He notified her that his trip to Washington was delayed because his wagon "is still employed in bringing away all things from Montpellier."[343]

President James Madison's death on June 28, 1836, left Montpelier without its animating spirit. The social life that Mrs. Smith and others had enjoyed there had ended. Madison's widow and stepson attempted to manage the plantation, but they sold it to a wealthy merchant from Richmond seven years later. Before the Civil War, the plantation changed hands four more times. In that time a family of English farmers attempted to practice improved farming methods, and a group of citizens erected monuments over the graves of James and Dolley Madison. The plantation also served as a status symbol for two wealthy Richmond businessmen. After the Madisons, the story of Montpelier in the 1840s and 1850s reflects the emerging sectional tension and depressed economy in antebellum Virginia.

CHAPTER EIGHT

Prior to Marion duPont Scott's gift of Montpelier to the National Trust for Historic Preservation in the mid-1980s, remembering the Madisons occurred only at the Madison family cemetery. Commemorative activities took place away from the house. In 1901, the duPont family altered the house to suit their needs. Now, a comprehensive restoration has changed the focus of President Madison in the public memory to the building he left us. The project has been daunting due to the massive additions built by the duPont family in the early twentieth century. Not only did they enlarge the mansion, but also the landscape changes of the duPonts, such as the steeplechase course and the numerous tenant residences and outbuildings for livestock, further obscured the historical landscape. Thus, the Madison family cemetery became the last place recognized as Madison.

Beginning in the 1850s, a group civic-minded citizens, including some Madison family members, started planning for the installation of a monolith above Madison's grave, according to an Orange County historian.[344] Dolley Madison had included a clause in her 1841 will that instructed her executors to erect "a plain monument of white marble over the remains of my dear Husband."[345] Her son never fulfilled this wish before his own death. So the task fell to more distant relations and admirers. Dolley's brother John C. Payne and James H. Causten considered the possibility of installing such a monument in early 1852. Causten wrote to Payne to suggest that he purchase the graveyard, with the intention of conveying it to the state at a later date. He hoped to get "influential Virginians" to enlist support and funding of the general assembly. Without the support of the state, "I will plan a plain slab over each; for it would be ridiculous for me to pretend to erect a monument."[346]

Payne identified various problems that they faced. First, other Madison family members may object to the state owning the graveyard where their other relations were interred. Secondly, Payne regretted leaving the matter

Madison Monument, circa 1908. *Courtesy of Library of Congress, Prints and Photographs Division, Washington, D.C.*

in the hands of Benjamin Thornton, the present owner of Montpelier (Moncure sold the farm in 1848), whom he called "the stranger." Also, raising funds for a monument to Madison would be slow to progress, they thought, like the public effort to erect the Washington monument. Payne admitted his own lack of financial resources to complete the project. Payne believed they would not have much support because the American public at large was not "a monumental people…Jefferson, Patrick Henry and a host of Worthies besides Washington & Madison have not found a mark placed over their place of rest by their native State."[347] In another letter to Causten, Payne again sought his help in carrying out the last wishes of Dolley Madison, but he was not optimistic that they would raise a monument. They were "powerless," he wrote. Therefore, he placed his hope in the following generations of Americans. "My faith is firm that posterity will do his character more justice than it now receives and that increasing veneration for it will secure a quiet repose to the remains which surround his own."[348] Payne and Causten placed a greater faith in the state of Virginia to preserve the memory of Madison than in the Madison family, the Thorntons or the federal government. Their suggestion that memorializing Madison in his grave was a burden best placed upon the Commonwealth of Virginia pointed to the continued sectional interest in the ex-president's legacy.

Newspaper accounts from the fall of 1857 and early 1858 recorded the activity at the Madison family cemetery. First, Madison's grave received

an obelisk monument, and then Dolley Madison's remains arrived from a Washington, D.C. cemetery. On September 15, 1857, the granite obelisk, which had arrived at Montpelier by rail from Richmond, was set in place above Madison's grave. Within three months, Dolley was reinterred beside him.

Documentation that names the subscribers to the memorial project has not come to light. Frederick Schmidt, a Montpelier historian, surmises that the most likely contributors were members of Madison's social circle: William Cable Rives, a political acolyte and early Madison biographer; Edward Coles, a family relation in Albemarle County; and John C. Payne, Dolley's only surviving brother.[349] These men were concerned not just with Madison's memory, but they were also curious about the state of his body. While laying up the monument's foundation, they found a reason to investigate the body's state of decomposition. His corpse, not his house, captured their attention; the article did not mention the condition of the mansion.[350]

By choosing an obelisk as a monument, the benefactors displayed an appreciation of Egyptian Revival forms, in particular their funereal symbolic associations and connotations of timelessness. At that time, Egyptian Revival forms were common in designs for memorials and tombs. The obelisk at Montpelier appeared toward the end of the Egyptian Revival movement, after many obelisk designs had been executed. The most obvious source for the design of Madison's memorial was Robert Mills's 1833 design for the Washington National Monument, which was under construction in 1848, but the obelisks designed by William Strickland in 1833 for the Washington family tomb at Mount Vernon may have inspired the Madison memorial planners as well. In the revival mode, obelisks marked focal points in the landscape, rather than flanking axial paths as in Egypt. The monument projected the durability of Madison's memory in a way that the house could not.[351]

The *Richmond Enquirer* published a detailed account of the exhumation and monument installation. The article noted that since Madison's death

> *no mural record with high sounding eulogy disclosed the place of his final rest, only neighborhood tradition and historic record serving to point the way to it. The neglect in attesting his worth by some suitable monument attracted attention, and some few years since a number of gentlemen of Orange County set about the task of procuring one. Having been procured, it was conveyed to Montpelier on the 15th Sept., and placed in position.*[352]

That the impetus for the erection of the monument was local in nature indicated the lack of national sympathy Madison's memory commanded. Moreover, the house failed to serve as a suitable public memorial.

The Richmond newspaper provided its readers with a detailed description of the monument, which was quarried by John W. Davies in Richmond. Composed of seven pieces, the monument weighed close to 32,000 pounds. It rose twenty-two and a half feet and bore the inscription "Madison, Born March 16, 1751, Died June 28, 1836."[353]

The excavation of ground for construction of the monument's base offered an opportunity for a glimpse of Madison's decomposed body. After removing the lid, the men found that "the interior was nearly filled with a species of moss, which adhered pertinaciously to the wood. Beneath this and partially hidden by it, were a few of the larger and harder bones." Madison's lower jaw "had fallen away, the bones of the breast and the ribs were gone, and the only parts of the skeleton which remained were the skull and portions of the cheek bones, the vertebrae of the neck, the spine and the large bones of the arms."[354]

The load of the obelisk above the grave required the construction of a barrel vault over the casket. Two walls were constructed on either side along with a brick arch over the coffin. A similar structure supported Dolley's obelisk. A few months later, Dolley's remains were hauled from Washington down to Montpelier and laid to rest beside her husband. The *Richmond Enquirer* reported that her nephew, Mr. Cutts, brought her remains from Washington. Her re-burial would "have been consummated when the Madison monument was erected in September last, if her relatives in Washington had known at the time that this was about being done."[355] Later, Dolley Madison's grave received an obelisk smaller than the president's, but the exact date of its installation has eluded historians. Some time between her interment at Montpelier in early 1858 and the arrival of Confederate troops in the area during the Civil War, it appeared in the family cemetery.[356]

The installation of the monuments over the graves of James and Dolley Madison briefly reasserted Montpelier in the antebellum American public sphere. The project to monumentalize him received notice in the Richmond press, as well as in national journals. For instance, *Frank Leslie's Illustrated Newspaper* carried an article on President Madison's obelisk at the time of Dolley Madison's re-interment at Montpelier. This article too focused on the exposure and condition of Madison's remains.[357] The movement of Confederate troops through the area during the Civil War, however, brought a renewal of interest in Madison, and the frequent transfers of ownership ceased, bringing a measure of stability to the plantation until the end of the rebellion.

At the cemetery in the first half of the twentieth century, the local chapter of the Daughters of the American Revolustion (DAR) provided an attendant to protect the cemetery against vandalism. Mrs. Scott provided labor from her staff for routine maintenance and repairs. The cemetery was open for visitors on Thursdays only. The attendant, William Adams, collected twenty-five cents per visitor. Adams claimed to be a former Montpelier slave, and he kept the admission fee as payment for his custodial work as part of the arrangement. Mrs. Scott had workers construct a small house for Adams adjacent to the graveyard. After his death in August 1935, no admission fee was charged and Adams's house was demolished.[358] Virginius R. Shackelford, an Orange County attorney and Mrs. Scott's lawyer, described her maintenance of the cemetery and defended her against criticisms that it was in a derelict condition. For instance, he wrote, "She has a space around it for the parking of cars and a small house where a caretaker is located on occasions although this is probably infrequent. The graves, the tombstones, and the trees are well preserved. There is the usual growth of periwinkle as found in old grave yards. It is not kept up in the formal sense that the grass is perfect and always cut, but it is certainly not neglected."[359]

Starting in the mid-1930s, the DAR chapter held an annual ceremony to maintain their presence at the Madisons' cemetery. They marked Constitution Day at the cemetery with speeches and visiting dignitaries until the 1970s. The same Orange County attorney, writing in 1936, recalled a Madison birthday event at the cemetery: "About two years ago a group of Constitutionalists headed by some newspaper men from Washington had a meeting at the grave yard in celebration of Madison's birthday…I recall very distinctly that the speeches were long and uninteresting and that the day was very hot."[360] Later in the 1960s, the nature of the ceremony changed. Mrs. Scott recalled, "Every year on Madison's birthday (March 16), the government sends an honor guard to Montpelier to perform a small ceremony in Madison's honor. School children often attend." She credited President Lyndon B. Johnson for starting this ritual.[361] Throughout the years, the chapter and Mrs. Scott repaired damage done by vandals to headstones and the Madisons' monuments and occasionally installed commemorative plaques on the cemetery's brick walls.

Following a June 1989 symposium sponsored by the Montpelier Foundation, commemoration of President Madison and Dolley Madison moved toward the house. William Seale, a prominent architectural historian, envisioned a recovery of Madison architecture. He recalled a site visit to Montpelier where, in his words, he found that "the renovation of the turn of the century did not obliterate all that James and Dolley Madison left, and through this house we can see the historic couple in greater depth than

we've ever known before." He described the house as "long and lanky" and "intriguing more than august." He was "delighted to find that Montpelier is a biographical house" like Mount Vernon and Monticello, "a building put up not for someone by someone else but a house that grew part by part with the man, and the woman." Montpelier, he believed, "is not lost to the age of Madison as we once supposed it was."[362]

Efforts to rescue the legacy of James and Dolley Madison in Montpelier soon followed. Prior to the restoration, exhibits in the main house hinted at the possibility and potential of a full restoration. For instance, the 1998 "Discovering Madison" exhibit featured the recreation of period rooms suggesting how certain interiors of the house may have appeared toward the end of Dolley and James Madison's lifetime. The 1998 exhibit marked a turning point in Montpelier's public interpretation program. By appearing at the home, the First Lady Hillary Clinton brought national recognition to the National Trust's interpretive efforts. The staff announced that Montpelier would be part of a White House Millennium Council and National Trust campaign called "Save America's Treasures." The National Trust pledged $8 million toward maintaining the mansion, with the Montpelier Trustees obliged to match that pledge. Since 1998, the Montpelier staff have enhanced the interior exhibit space with a display of period and reproduction furnishings and food in the dining room to recreate the 1824 visit of General Lafayette. This exhibit enjoyed favorable publicity, as its opening was tied to James Madison's 250th birthday celebration on March 16, 2001.[363]

Since 2003, the National Trust has initiated substantial changes to their interpretation and management of Montpelier. The National Trust no longer oversees the day-to-day operation of the museum property, having transferred those responsibilities to the nonprofit Montpelier Foundation, which was incorporated in 1998, through a long-term lease in September 2000. The Montpelier Foundation and its benefactors funded the construction of a new visitor center and the establishment of a Constitutional Studies Center on the property. Most importantly, the foundation embarked on a restoration of the house to its appearance and internal structure after President Madison's final remodeling in 1811.

The curatorial staff has continued to develop exhibitions for public display. They have begun acquiring authentic pieces of Madison furniture and decorative arts for display. In March 2001, a recreation of the Madison dining room as it might have appeared for a banquet in honor of the Marquis de Lafayette in 1824 opened to the public. An exhibit, "The Madisons' Style and Taste," featuring recent acquisitions of Madison furniture and artwork, opened in 2001. To raise the visibility of President Madison's contribution

to the Louisiana Purchase and the Lewis and Clark expedition, the curators developed an exhibit entitled "James Madison: Secretary of State in an Age of Expansion & Exploration," which opened in January 2003.

Of all these developments, the effort to remove the duPont additions to the house are the most dramatic. In the fall of 2001, an exhaustive investigation of the house began. Supported by a Paul Mellon grant, the investigation utilized the latest tools of architectural analysis, including paint analysis, measured drawings, subsurface data recovery and Computer Aided Drafting and Design (CADD) data coordination. Based on the results of the survey, which indicated that enough of the house remains in place to guide a restoration, the Montpelier Foundation and its benefactors have restored with historical accuracy the mansion as it stood in the early nineteenth century.

NOTES

INTRODUCTION

1. Mills Lane, *Architecture of the Old South: Virginia* (Savannah, GA: The Beehive Press, 1987), 103; Camille Wells, "The Multi-Storied House: Twentieth Century Encounters with the Domestic Architecture of Colonial Virginia," *Virginia Magazine of History and Biography* 106 (Fall 1998): 353–418.

CHAPTER ONE

2. Edmund S. Morgan, *American Slavery American Freedom: The Ordeal of Colonial Virginia* (New York: W.W. Norton & Company, 1975), 171–73, 219, 405–06; Lorena S. Walsh, "Slave Life, Slave Society, and Tobacco Production in the Tidewater Chesapeake, 1620–1820," in *Cultivation and Culture: Labor and the Shaping of Slave Life in the Americas*, ed. Ira Berlin and Philip D. Morgan (Charlottesville: The University Press of Virginia, 1993), 181.

3. Nell Marion Nugent, abs. *Cavaliers and Pioneers: Abstracts of Virginia Patents and Grants*, Vol. III, 1695–1732 (Richmond: Virginia State Library, 1979), 257.

4. Madison Account Book 1725–1726, Shane Collection; Nugent, *Cavaliers and Pioneers*, 151, 219, 299, 319, 352, 389; Spotsylvania County Order Book, November 1726, 113; Spotsylvania County Will Book A, 42–43.

5. Rhys Isaac, *The Transformation of Virginia, 1740–1790* (Chapel Hill: The University of North Carolina Press for the Institute of Early American History and Culture, 1982), 33; designated site number 44OR219, past excavations there revealed post molds, stone foundation sections and cellar and kitchen features containing a variety of mid-eighteenth-century domestic artifacts; Lynne G. Lewis, "Archaeological Survey and the History of Orange County: Another View from Montpelier," *Quarterly Bulletin*, Archaeological Society of Virginia 44 (1988): 153; Matthew Reeves, "Examining a Pre-Georgian Plantation Landscape in Piedmont Virginia: The Original Madison Family Plantation, 1726–1770" (presented at the Society for Historical Archaeology Conference, Providence, RI, 2003).

6. Cary Carson, Norman F. Barka, William M. Kelso, Garry Wheeler Stone and Dell Upton, "Impermanent Architecture in the Southern American Colonies," in *Material Life in America, 1600–1860*, ed. Robert Blair St. George (Boston: Northeastern University Press, 1988), 131, 137; Reeves, "Pre-Georgian Plantation."

7. Spotsylvania County Will Book, A: 182–86; Dell Upton, "Vernacular Domestic Architecture in Eighteenth-Century Virginia," *Winterthur Portfolio* 17 (1982): 98, 103; Mark R. Wenger, "The Central Passage in Virginia: Evolution of an Eighteenth-Century Living Place," in *Perspectives in Vernacular Architecture II*, ed. Camille Wells (Columbia: University of Missouri Press, 1986), 142, 149.

8. Lorena S. Walsh, *From Calabar to Carter's Grove: The History of a Virginia Slave Community* (Charlottesville: The University Press of Virginia, 1997), 205; Spotsylvania County Order Book, August 6, 1728, 239; Irving Brant, *James Madison: The Virginia Revolutionist* (New York: The Bobbs-Merrill Co., 1941), 24, 26–27, 47, 405–06 n. 17; Spotsylvania County Order Book, June 16, 1732, 126; Spotsylvania County Will Book A, 42–43.

9. Spotsylvania County Order Book, August 3, 1732, 142; September 7, 1732, 159–60. The third suit mentioned only a debt, not specific trespassing damages. The second and third suits were dismissed for the following reason: "the Plaintiff being Dead."

10. Spotsylvania County Order Book, September 6, 1732, 151.

11. Ira Berlin, *Many Thousand Gone: The First Two Centuries of Slavery in North America* (Cambridge: The Belknap Press of Harvard University Press, 1998), 111, 115, 120, 123; Philip D. Morgan, "Slave Life in Piedmont Virginia, 1720–1800," in *Colonial Chesapeake Society*, ed. Lois Green Carr, Philip D. Morgan and Jean B. Russo (Chapel Hill: The University of North Carolina Press, for the Institute of Early American History and Culture, 1988), 443.

12. W.W. Scott, *A History of Orange County* (Richmond: Everett Waddey Co., 1907), 35, 135–36.

13. Morgan, "Slave Life," 439–49; Berlin, *Many Thousand Gone*, 110, 111, 122.

14. Spotsylvania County Will Book A, 172–73, 183–86; Lois Green Carr and Lorena S. Walsh, "Economic Diversification and Labor Organization in the Chesapeake, 1650–1820," in *Work and Labor in Early America*, ed. Stephen Innes (Chapel Hill: The University of North Carolina Press, for the Institute of Early American History and Culture, 1988), 162, 163, 171; Philip D. Morgan, "Task and Gang Systems: The Organization of Labor on New World Plantations,"in *Work and Labor in Early America*, ed. Stephen Innes (Chapel Hill: The University of North Carolina Press, for the Institute of Early American History and Culture, 1988), 200, 213.

15. Walsh, *From Calabar to Carter's Grove*, 90; Robert McColley, *Slavery and Jeffersonian Virginia* (2nd ed., Urbana: University of Illinois Press, 1973), 62.

16. Anne Elizabeth Yentsch, *A Chesapeake Family and Their Slaves: A Study in Historical Archaeology* (Cambridge: Cambridge University Press, 1994), 149–67; Carr and Walsh, "Economic Diversification," 177.

17. Walsh, *From Calabar to Carter's Grove*, 181.

18. Spotsylvania County Will Book A, 172–73, 183–86.

19. Lois Green Carr and Lorena S. Walsh, "Changing Lifestyles and Consumer Behavior in the Colonial Chesapeake," in *Of Consuming Interests: The Style of Life in the Eighteenth Century*, ed. Cary Carson, Ronald Hoffman and Peter J. Albert (Charlottesville: The University Press of Virginia for the United States Capitol Historical Society, 1994), 69.

20. Brant, *James Madison*, 26–27.

21. Spotsylvania County Order Book, February 6, 1733, 182.

22. Spotsylvania County Order Book, June 5, 1734, 326.

CHAPTER TWO
23. Orange County Deed Book 2, 10.

24. Orange County Order Book 2, 76, 87.

25. T.H. Breen, *Tobacco Culture: The Mentality of the Great Tidewater Planters on the Eve of Revolution* (Princeton, NJ: Princeton University Press, 1985).

26. Brant, *James Madison*, 27; Spotsylvania County Will Book A, 183; Daniel Samport to Ambrose Madison, November 21–22, 1729, Shane Manuscript Collection, Sh18 M 265 #3 and #4 (mf.), reel no. 149, Presbyterian Historical Society, Philadelphia; John Madison to Ambrose Madison, March 16, 1731/32, Sh18 M 265 #5 (mf.), reel 149; Hunt &

Waterman to Mrs. Frances Madison, February 23, 1750, DS, Shane Collection, Sh18 M 265 #9 (mf.) reel 149.

27. Thomas Jefferson, *Notes on the State of Virginia*, ed. William Peden (New York: W.W. Norton & Co., for the Institute of Early American History and Culture at Williamsburg, Virginia, 1982), 94; William Cronon, *Nature's Metropolis: Chicago and the Great West* (New York: W.W. Norton & Co., 1991), xix, 266–67; Kenneth E. Lewis, *The American Frontier: An Archaeological Study of Settlement Pattern and Process* (Orlando: Academic Press, 1984).

28. Orange County Minute Books 1, 141, 303; Orange County Minute Books 3, 135, 360; Orange County Minute Books 5, 180, 213, 236, 312, 373, 423, 437, 480; Orange County Minute Books 6, 106, 154, 552; Orange County Minute Books 7, 5, 370, 462, 542; Orange County Minute Books 8, 130, 251, 266; James Madison to James Madison Sr., January 23, 1778; *Papers of James Madison* 1, 223–24; Brant, *James Madison*, 51.

29. Colonel James Madison Sr., Account Book, 1744–55, University of Virginia, Alderman Library, Special Collections, Acc.#10558, account with James Barnett, 28–58; manuscript copy on file in Montpelier Archives.

30. Colonel James Madison Sr., Account Book, 1744–57, 10; Carville Earle and Ronald Hoffman, "Urban Development in the Eighteenth-Century South," in *Perspectives in American History* X, eds. Donald Fleming and Bernard Bailyn (1976), 7–78.

31. Colonel James Madison Sr., Account Book, 1744–57, 51.

32. Ibid., 43, 50, 52.

33. Ibid., 55.

34. Reverend Henry Fry, Account Book, 1759–95, Virginia Papers, Fry-McLemore Collection, University of Virginia, Alderman Library, Box 1, Mss 10659-a, 14, 28, 134, 180.

35. Orange County Order Book 5, 392, November 23, 1752; Orange County Order Book 5, 486, August 23, 1753.

36. Orange County Minute Book 3, 55, October 26, 1790; Orange County Minute Book 6, 301, November 25, 1756.

37. Orange County Deed Book 12, 228, 229; Orange County Deed Book 13, 260.

38. Orange County Deed Book 12, 201, March 27, 1754.

39. Colonel James Madison Sr., Account Book, 1744–57, 53.

40. Carson et al., "Impermanent Architecture," 147–48.

41. Edward A. Chappell, "Housing a Nation: The Transformation of Living Standards in Early America," in *Of Consuming Interests: The Style of Life in the Eighteenth Century*, ed. Cary Carson, Ronald Hoffman and Peter J. Albert (Charlottesville: The University Press of Virginia for the United States Capitol Historical Society, 1994), 171.

42. Kevin M. Sweeney, "High-Style Vernacular: Lifestyles of the Colonial Elite," in *Of Consuming Interests: The Style of Life in the Eighteenth Century*, ed. Cary Carson, Ronald Hoffman and Peter J. Albert (Charlottesville: The University Press of Virginia for the United States Capitol Historical Society, 1994), 1–58.

43. Edward Chappell, Willie Graham, Carl R. Lounsbury and Mark R. Wenger, "Architectural Analysis and Recommendations for Montpelier, Orange County, Virginia" (Colonial Williamsburg Foundation for the National Trust for Historic Preservation, June 1997), 5, 6. A more recent investigation of the building occurred in the 2001–02 winter as a first step in restoring the house to President Madison's time period. Conducted by Mark R. Wenger, the investigation produced evidence relating to interior wall treatments, changes to window and doorway apertures and the types of door hardware installed during President Madison's occupancy of the house; see Friends of James Madison's Montpelier, *Discovering Montpelier* (Winter 2003), 9.

44. Wenger, "Central Passage," 149.

45. Account Book of Colonel James Madison Sr. of Montpellier, Orange County, 1776–98, 88.

46. Edward Chappell, "Williamsburg Architecture as Social Space," *Fresh Advices* (1981): i–iv; Edward Chappell, "Looking at Buildings," *Fresh Advices* (1984): i–vi.

47. Upton, "Vernacular Domestic Architecture," *Winterthur Portfolio* 17 (2/3): 102.

48. Edward Chappell, "Slave Housing," *Fresh Advices* (1982): i–ii, iv; Upton, "Vernacular Domestic Architecture"; Camille Wells, "The Planter's Prospect: Houses, Outbuildings, and Rural Landscapes in Eighteenth-Century Virginia," *Winterthur Portfolio* 28 (1): 1–31.

49. Charles L. Perdue Jr., Thomas E. Barden and Robert K. Phillips, eds., *Weevils in the Wheat: Interviews with Virginia Ex-Slaves* (Charlottesville: The University Press of Virginia: 1992), 227.

50. Mark R. Wenger, "The Dining Room in Early Virginia," *Perspectives in Vernacular Architecture III*, ed. Thomas Carter and Bernard L. Herman (Columbia: The University of Missouri Press, 1989), 149–59; Chappell et al., "Architectural Analysis," 10.

51. Chappell et al., "Architectural Analysis," 12.

52. Colonel James Madison Sr. to Clay & Midgely, merchants of Liverpool, June 19, 1770, DS, Shane Collection, Sh18 M 265 #9 (mf.) reel 149.

53. Scott, *A History of Orange County*, 73; James Madison to James Madison Sr., March 10, April 25, May 19, 1794, *Papers of James Madison* 15, 276, 314, 335.

54. Wells, "Planter's Prospect," 1–31.

55. *Hite v. Madison*, 1835–36 suit in chancery, Madison County Circuit Court, microfilm on file, Library of Virginia, Richmond.

56. Account Book of Colonel James Madison Sr. of Montpellier, Orange County, 1776–98, Misc. Reel 8, Personal Papers Collection, 28529, VASV97-A266, The Library of Virginia, Richmond; University of Virginia, Papers of James Madison, Alderman Library, 2-a, 16, 19, 40a.

57. Account Book of Colonel James Madison Sr. 17, 56, 78, 90.

58. Ibid., 2, 42, 43, 57, 60.

59. Account Book of Colonel James Madison Sr. of Montpellier, Orange County, 1776–98, 94.

60. Account Book of Colonel James Madison Sr. of Montpellier, Orange County, 1798–1817, 4.

61. Larry Dermody, "Fire and Ice: The Col. James Madison Ironworks at Montpelier, 1762–1801" (paper presented at the Society for Historical Archaeology 1992 Annual Conference, January 1992, Kingston, Jamaica). Copy on file at Montpelier Archives.

62. Colonel Madison's account with Henry Miller of Mossy Creek in 1777 showed payment for smith work made by "1 Tun of Bar Iron, Castings, a pot, 20# Sweedish Steel"; his account with John Alcock mentioned German steel. Account Book of Colonel James Madison Sr. of Montpellier, Orange County, 1776–98, 49, 82.

63. McColley, *Slavery and Jeffersonian Virginia*, 19.

64. Robert B. Gordon, *American Iron, 1607–1900* (Baltimore: Johns Hopkins University Press, 1996), 7, 125–33.

65. Account Book of Colonel James Madison Sr. of Montpellier, Orange County, 1776–98, 13, 46, 56.

66. Orange County Will Book, 4, 5–7.

67. *Hite v. Madison*.

68. "1776, Mr. James Coleman, my Overseer, Dr."; account Book of Colonel James Madison Sr. of Montpellier, Orange County, 1776–98, 30.

69. Account Book of Colonel James Madison Sr. of Montpellier, Orange County, 1776–98, 93. James Madison hired Peter out for five months to James Coleman in 1791.

70. Account Book of Colonel James Madison Sr. of Montpellier, Orange County, 1776–98, 40, 88.

71. *Hite v. Madison.*

72. "1776, Mr. James Coleman, my Overseer, Dr."; account Book of Colonel James Madison Sr. of Montpellier, Orange County, 1776–98, 30.

73. Account Book of Colonel James Madison Sr., 81, 82.

74. Ibid., 82.

75. Ibid., 92, 93.

76. Orange County, Virginia, Personal Property Tax List, 1782–1880, Library of Virginia, reel 262.

77. James Madison Jr. to James Madison Sr., March 29, 1777, *Papers of James Madison* 1, 190.

78. Richard S. Dunn, "Black Society in the Chesapeake, 1776–1810," in *Slavery and Freedom in the Age of the American Revolution*, eds. Ira Berlin and Ronald Hoffman (Charlottesville: The University Press of Virginia for the United States Capitol Historical Society, 1983), 74.

79. Orange County Land Tax Book, microfilm reels, Library of Virginia; Orange County, Virginia, Personal Property Tax List, 1782–1880, Library of Virginia, reel 262.

80. Berlin, *Many Thousand Gone*, 266–68; Dunn, "Black Society," 50.

81. James Madison Jr. to James Madison Sr., September 8, 1783, *Papers of James Madison* 7, 304.

82. Dunn, "Black Society," 52, 80.

CHAPTER THREE

83. *The Papers of James Madison* 1, 192.

84. Edmund Pendleton to James Madison Jr., July 6, 1781, *Papers of James Madison* 3, 172.

85. *Papers of James Madison* 2, 48.

86. Orange County Deed Book 17, 425.

87. Orange County Will Book 4, 1–5.; Ann L. Miller, *Antebellum Orange: The Pre–Civil War Homes, Public Buildings, and Historic Sites of Orange County, Virginia* (Orange County Historical Society, Inc., 1988), 28.

88. Orange County Will Book 4, 1–5.

89. T.O. Madden Jr. with Ann L. Miller, *We Were Always Free: The Maddens of Culpeper County, Virginia, A 200-Year Family History* (New York: W.W. Norton & Co., Inc., 1992), 2, 6, 11–14, 17–39.

90. Orange County Will Book 4, 1–5.

91. James Madison Sr. to James Madison Jr., January 30, 1788, *Papers of James Madison* 10, 447.

92. Orange County Deed Book 18, 404. This transfer was recorded August 25, 1785, and the following slaves moved across the Blue Ridge Mountains to Belle Grove: "Jimmy, Jerry, Eliza and her five children, to wit Joanna, Dianna, Domas, Tender, and Webster, also Treslove and her four children to wit, Peggy, Priscilla, Henry, and Katy, also Sally and Milly."

93. Orange County Will Book 4, 1–5.

94. Orange County Deed Book 16, 378.

95. Orange County Deed Book 18, 316.

96. Orange County Deed Book 20, 127, July 8, 1792.

97. Orange County Land Book, microfilm reels, Library of Virginia.

98. Orange County Deed Book 20, 229, September 16, 1793.

99. Fontaine Maury to James Madison, June 14, 1789, *Papers of James Madison* 12, 218.

100. Orange County, Virginia, Personal Property Tax List, 1782–1800, reel 262, Library of Virginia.

101. Instructions for the Montpelier Overseer and Laborers, November 8, 1790, *Papers of James Madison* 13, 303–04.

102. James Madison to Thomas Jefferson, June 19, 1793, *Papers of James Madison* 15, 33–34.

103. James Madison Jr. to James Madison Sr., February 21, 1794, *Papers of James Madison* 15, 262–63.

104. James Madison Sr. to James Madison Jr., March 15, 1794, *Papers of James Madison* 15, 285–86.

105. James Madison Jr. to James Madison Sr., April 25, 1794, *Papers of James Madison* 15, 314.

106. Orange County Land Book, microfilm reels, Library of Virginia.

107. James Madison Jr. to James Madison Sr., November 10, 1794, *Papers of James Madison* 15, 372.

108. Fontaine Maury's nephew, Commodore Matthew Fontaine Maury, gained international acclaim for his work in oceanic cartography. See John W. Wayland, *The Pathfinder of the Seas: The Life of Matthew Fontaine Maury* (Richmond: Garrett and Massie, Inc., 1930), and Frances Leigh Williams, *Matthew Fontaine Maury, Scientist of the Sea* (New Brunswick: Rutgers University Press, 1963), 14.

109. Fontaine Maury to James Madison, June 14, 1789, *Papers of James Madison* 12, 218.

110. James Madison Jr. to James Madison Sr., May 2, 1790, *Papers of James Madison* 13, 183.

111. James Madison Jr. to Ambrose Madison, November 16, 1786, *Papers of James Madison* 9, 168

112. James Maury to James Madison, October 6, 1789, *Papers of James Madison* 12, 430.

113. James Madison to R. Thomas Martin, August 10, 1769, *Papers of James Madison* 1, 43.

114. Fontaine Maury to James Madison, July 20, 1790, *Papers of James Madison* 13, 280–81.

115. Orange County Deed Book 32, 227–28.

116. Orange County Will Book 4, 1–7.

117. Matthew Hyland, "African-American Cemetery at Montpelier, Orange County, Virginia: Survey and Interpretations" (report prepared for the National Trust for Historic Preservation, June 1998, on file at Montpelier).

118. Walsh, *From Calabar to Carter's Grove*, 95.

119. Ross W. Jamieson, "Material Culture and Social Death: African-American Burial Practices," *Historical Archaeology* 29 (1995): 39–58.

120. Grey Gundaker, "At Home on the Other Side: African American Burials as Commemorative Landscapes," in *Places of Commemoration: Search for Identity and Landscape Design*, ed. Joachim Wolschke-Bulman (Washington, D.C.: Dumbarton Oaks Colloquium on the History of Landscape Architecture, XIX, Dumbarton Oaks Research Library and Collection, 2001), 25–54.

121. Perdue et al., *Weevils in the Wheat*, 289.

122. Orange County, Virginia, Personal Property Tax List and Land Book, 1782–1880, Library of Virginia, microfilm reel 262.

123. Orange County Will Book 3, 318–20.

124. Ibid., 320.

125. Yentsch, *Chesapeake Family*, 149–67.

126. Account Book of Colonel James Madison Sr. of Montpellier, Orange County, 1776–98, 13.

127. James Madison Jr. to James Madison Sr., March 10, 1794, *Papers of James Madison* 15, 276, 384.

128. Ibid., May 4, 1794, *Papers of James Madison* 15, 323.

129. Ibid., October 5, 1794, *Papers of James Madison* 15, 361.

130. Ibid., August 10, 1796, *Papers of James Madison* 1, 390.

131. Bernard L. Herman, "The Model Farmer and the Organization of the Countryside," in *Everyday Life in the Early Republic*, ed. Catherine E. Hutchins (Winterthur, DE: The Henry Francis duPont Winterthur Museum, Inc., 1994), 49, 50.

132. Orange County Will Book 4, 1–5, 54–57; Orange County Will Book 5, 242–46.

133. Sarah Pattee Stetson, "American Garden Books Transplanted and Native, before 1807," *William and Mary Quarterly*, 3d series, 3 (July 1946): 347, 351.

134. Orange County Will Book 4, 1–5.

135. John Wayles to Farrell and Jones, August 30, 1766, in "John Wayles Rates his Neighbours," ed. John M. Hemphill II, *Virginia Magazine of History and Biography LXVI (1958): 305.*

Chapter Four

136. John Brinckerhoff Jackson, *Discovering the Vernacular Landscape* (New Haven: Yale University Press, 1984), 12–54.

137. Robert Dalzell Jr., "Constructing Independence: Monticello, Mount Vernon and the Men Who Built Them," *Eighteenth-Century Studies* 26 (Summer 1993): 543–80; Robert F. Dalzell Jr. and Lee Baldwin Dalzell, *George Washington's Mount Vernon: At Home in Revolutionary America* (New York: Oxford University Press, 1998); Jack McLaughlin, *Jefferson and Monticello: The Biography of a Builder* (New York: Henry Holt and Company, 1990).

138. Conover Hunt-Jones, *Dolley and the "Great Little Madison"* (Washington, D.C.: American Institute of Architects Foundation, 1977), 61–62.

139. Robert E. Shalhope, "Toward a Republican Synthesis: The Emergence of an Understanding of Republicanism in American Historiography," *William and Mary Quarterly*, 3d series, 29 (January 1972): 49–80; Daniel T. Rodgers, "Republicanism: the Career of a Concept," *The Journal of American History* 79 (June 1992): 11–38; Drew R. McCoy, *The Elusive Republic: Political Economy in Jeffersonian America* (Chapel Hill: The University of North Carolina Press for the Institute of Early American History and Culture, 1980); Drew R. McCoy, *The Last of the Fathers: James Madison and the Republican Legacy* (New York: Cambridge University Press, 1989); Ralph Ketcham, *James Madison: A Biography* (Charlottesville: The University Press of Virginia, 1990); Brant, *James Madison.*

140. James Madison to Thomas Jefferson, May 8, 1793, *Papers of James Madison* 15, 13.

141. Thomas Jefferson to James Madison, May 19, 1793, *Papers of James Madison* 15, 18.

142. James Madison to Thomas Jefferson, June 19, 1793, *Papers of James Madison* 15, 33–34.

143. Thomas Jefferson to James Madison, June 29, 1793, *Papers of James Madison* 15, 41, 154.

144. Ibid., September 20, 1785, *Papers of Thomas Jefferson* 8, 366.

145. James Madison to Thomas Jefferson, October 5, 1794, *Papers of James Madison* 15, 360.

146. Wenger, "Central Passage," 149.

147. James Monroe to James Madison, January 20, 1796, *Papers of James Madison* 16, 197.

148. Ibid.

149. James Monroe to Thomas Jefferson, September 7, 1794, and November 18, 1795, *The Writings of James Monroe*, ed. Stanislaus Murray Hamilton (New York: AMS Press, 1969) 2: 54, 411–12.

150. James Monroe to James Madison, November 30, 1794, *Papers of James Madison* 15, 403.

151. Memorandum to James Monroe, March 26, 1795, *Papers of James Madison* 15, 498.

152. James Madison to James Monroe, January 25, 1796, *Papers of James Madison* 16, 202–03; Hunt-Jones, *Dolley*, 18.

153. James Madison correspondences with James Monroe, October 23, 1795, November 8, 1795, January 25, 1796, *Papers of James Madison* 16, 106, 124, 202–03.

154. James Madison to James Monroe, April 7, 1796, and May 14, 1796, *Papers of James Madison* 16 303–58.

155. Kenneth Ames, "Designed in France: Notes on the Transmission of French Style to America," *Winterthur Portfolio* 12 (1977): 103–14.

156. Katharine Anthony, *Dolly Madison: Her Life and Times* (Garden City, NY: Doubleday & Co., Inc., 1949), 30–33.

157. James Blair to James Madison, April 25, 1797, *Papers of James Madison* 17, 2.

158. Joseph Mussi to James Madison, December 1797, *Papers of James Madison* 17, 57.

159. Ketcham, *James Madison*, 368.

160. James Monroe to James Madison, December 10, 1797, *Papers of James Madison* 17, 60.

161. Tamara Plakins Thornton, *Cultivating Gentlemen: The Meaning of Country Life among the Boston Elite, 1785–1860* (New Haven: Yale University Press, 1989), 44–46, 52–56.

162. Jack McLaughlin, *Jefferson and Monticello: The Biography of a Builder* (New York: Henry Holt, 1988), 262.

163. James Monroe to James Madison, December 10, 1797, *Papers of James Madison* 17, 60.

164. Thomas Jefferson to James Madison, November 17, 1798, *Papers of James Madison* 17, 175.

165. Ibid., October 26, 1798, *Papers of James Madison* 17, 169.

166. Ibid., November 3, 1798, *Papers of James Madison* 17, 173.

167. Ibid., November 17, 1798 *Papers of James Madison* 17, 175.

168. James Madison to Thomas Jefferson, December 11, 1798, *Papers of James Madison* 17, 184.

169. Thomas Jefferson to James Madison, January 3, 1798, *Papers of James Madison* 17, 65.

170. James Madison to Thomas Jefferson, August 12, 1800, *Papers of James Madison* 17, 400–01.

171. Ibid., December 25, 1799, *Papers of James Madison* 17, 63

172. Thomas Jefferson to James Madison, August 23, 1799, *Papers of James Madison* 17, 257.

173. James Madison to Thomas Jefferson, August 12, 1800, *Papers of James Madison* 17, 400–01.

174. James Monroe to James Madison, September 25, 1798, *Papers of James Madison* 17, 168.

175. James Madison to James Monroe, November 10, 1798, *Papers of James Madison* 17, 174–75.

176. Ibid., December 11, 1798, *Papers of James Madison* 17, 184.

177. James Monroe to James Madison, July 13, 1799, *Papers of James Madison* 17, 253.

178. James Madison to James Monroe, July 20, 1799, *Papers of James Madison* 17, 254.

179. Ibid., February 5, 1798, *Papers of James Madison* 17, 74.

180. James Madison to Thomas Jefferson, April 29, 1798, *Papers of James Madison* 17, 122–23.

181. James Monroe to James Madison, November 22, 1799, *Papers of James Madison* 17, 278–79.

182. James Madison to Thomas Jefferson, April 4, 1800, *Papers of James Madison* 17, 377.

183. Thomas Jefferson to James Madison, May 12, 1800, *Papers of James Madison* 17, 387.

184. James Madison to Thomas Jefferson, August 12, 1800, *Papers of James Madison* 17, 400–01.

185. Account Book of Colonel James Madison Sr. of Montpellier, Orange County, 1798–1817, microfilm on file at the office of the Papers of James Madison, Alderman Library, University of Virginia, and Library of Virginia, (VASV97-A266), Misc. Reel 8, 20.

186. Wenger, "Central Passage," 149.

187. Thomas Jefferson to James Madison, May 11, 1789, *Papers of James Madison* 12, 152; Thomas Appleton to James Madison, September 8, 1802, *Papers of James Madison Secretary of State Series* 3, 559.

188. *Diaries of Mrs. Anna Maria Brodeau William Thornton, 1793–1863*, mss. 13,818, Alderman Library, Charlottesville, reel 2: 214, 222, 416.

189. Dolley P. Madison to Mrs. and Dr. Thornton, August 26, 1807, Mss. Coll #47, Madison/Payne Family Papers, Greensboro Historical Museum Archive; Margaret Bailey Tinkcom, "Caviar along the Potomac: Sir Augustus John Foster's 'Notes on the United States,' 1804–1812," *William and Mary Quarterly*, 3rd series, 8 (January 1951): 96–97.

190. Tinkcom, "Caviar along the Potomac," 90, 98.

191. Thomas Newton to James Madison, June 11, 1802, June 22, 1802, July 19, 1802, *Papers of James Madison, Secretary of State Series* 3, 301, 330, 404.

192. Tinkcom, "Caviar along the Potomac," 97, 98.

193. Douglas R. Egerton, *Gabriel's Rebellion: The Virginia Slave Conspiracies of 1800 and 1802* (Chapel Hill: The University of North Carolina Press, 1993), 148–67.

CHAPTER FIVE

194. Garry Wills, "Jefferson's Other Buildings," *The Atlantic* (January 1993): 80, 83; Wills argues that Montpelier reveals aspects of Jefferson's mind. Only the correspondence from Jefferson does that. The building is Madison.

195. James Dinsmore to James Madison, November 21, 1809, *Papers of James Madison, Presidential Series* 2, 77–78.

196. James Madison to James Dinsmore, December 16, 1809, *Papers of James Madison, Presidential Series* 2, 135.

197. Thomas Jefferson to James Madison, September 23, 1808, *Papers of Thomas Jefferson*, Library of Congress.

198. James Dinsmore to James Madison, May 4, 1809, *Papers of James Madison, Presidential Series* 1, 165.

199. Ibid., May 16, 1809, *Papers of James Madison, Presidential Series* 1, 188.

200. Fiske Kimball, *Thomas Jefferson, Architect* (Boston: Riverside Press, 1916), 169; James S. Ackerman, *The Villa: Form and Ideology of Country Houses*, Bollingen Series 35 (Princeton: Princeton University Press, 1990), 203.

201. "Carpenter's Bills for Montpelier, 1810–1812," Papers of John Hartwell Cocke, mss. 5680, 640, etc., Box 9, Alderman Library, University of Virginia.

202. Thomas Jefferson to James Madison, April 19, 1809, item no. A91, Carter G. Woodson Collection, Library of Congress, Washington, D.C.

203. James Dinsmore to James Madison, October 29, 1809, *Papers of James Madison, Presidential Series* 2, 44.

204. Mary Cutts, "Life at Montpelier, as Remembered by a Niece of Dolley Madison," ca. 1855, Montpelier Monograph 01-F0323, Cutts Papers, Library of Congress, photocopy at Montpelier Archives.

205. Baron de Montlezun, "A Frenchman Visits Norfolk, Fredericksburg, and Orange County, 1816," trans. L.G. Moffatt and J.M. Carrière, *Virginia Magazine of History and Biography* 53 (April/July 1945), 198.

206. "Carpenter's Bills for Montpelier, 1810–1812."

207. George C. Shattuck Jr. to Dr. George C. Shattuck, January 24, 1835, Massachusetts Historical Society, Boston, copy at Montpelier Archives.

208. Margaret Bayard Smith, *The First Forty Years of Washington Society* (New York: C. Scribner's Sons, 1906), 81.

209. Mark R. Wenger, "Thomas Jefferson and the Vernacular Tradition" (unpublished manuscript presented at "Thomas Jefferson, Architect," University of Virginia, Department of Architectural History symposium, Charlottesville, Virginia, November 1993); Marlene Elizabeth Heck, "Building Status: Pavilioned Dwellings in Virginia," in *Shaping Communities, Perspectives in Vernacular Architecture* 6, ed. Carter L. Hudgins and Elizabeth Collins Cromley (Knoxville: The University of Tennessee Press, 1997), 50, 54, 56.

210. Elizabeth Langhorne, K. Edward Lay, William D. Rieley, eds., *A Virginia Family and Its Plantation Houses* (Charlottesville: The University Press of Virginia, 1987), 70, 74–77.

211. Susan Holway Hellman, "Oak Hill, James Monroe's Loudoun Seat" (master's thesis, the University of Virginia, 1997), 24–35.

212. Ralph D. Gray, ed., "A Tour of Virginia in 1827: Letters of Henry D. Gilpin to his Father," *Virginia Magazine of History and Biography* 76, no. 3 (October 1968): 470.

213. Smith, *Washington Society*, 81–82.

214. "Carpenter's Bills for Montpelier, 1810–1812."

215. Hunt-Jones, *Dolley*, 75–89.

216. Smith, *Washington Society*, 233–34.

217. Gray, "Tour of Virginia," 468–69.

218. Hunt-Jones, *Dolley*, 94, 120; list of articles in dining room at Montpelier July the 1st '36, the Papers of Dolley P. Madison, Mss. 18,940, Library of Congress; J.D. Elliott to Dolley P. Madison, October 10, 1834, the Papers of Dolley P. Madison, Mss. 18,940.

219. Brant, *James Madison*, 397–98.

220. Hunt-Jones, *Dolley*, 86; John Davis Hatch, "John Vander Lyn's Prints of Niagara Falls," *The Magazine Antiques* (December 1990): 1252–61.

221. Harriet Martineau, *Retrospect of Western Travel (1838; reprint, New York: Harper & Brothers, 1942), 195.*

CHAPTER SIX

222. William M. Kelso and Rachel Most, eds., *Earth Patterns: Essays in Landscape Archaeology* (Charlottesville: The University Press of Virginia, 1990); Rebecca Yamin and Karen Beschere Metheny, eds., *Landscape Archaeology: Reading and Interpreting the American Historical Landscape* (Knoxville: The University of Tennessee Press, 1996); Pierce Lewis, "Learning from Looking: Geographic and Other Writing about the American Cultural Landscape," *American Quarterly* 35 (1983): 242–61; Pierce Lewis, "Common Landscapes as Historic Documents," in *History from Things, Essays on Material Culture*, eds. Steven Lubar and W. David Kingery (Washington, D.C.: The Smithsonian Institution Press, 1993), 115–39; J. Edward Hood, "Social Relations and the Cultural Landscape," in *Landscape Archaeology*, eds. Yamin and Metheny, 123, 124; Mark Leone, "The Georgian Order as the Order of Merchant Capitalism in Annapolis, Maryland," in *The Recovery of Meaning: Historical Archaeology in the Eastern United States*, eds. Mark P. Leone and Parker B. Potter Jr. (Washington, D.C.: The Smithsonian Institution Press, 1988), 255; Mark P. Leone and Paul Shackel, "Plane and Solid Geometry in Colonial Gardens in Annapolis, Maryland," in *Earth Patterns*, eds. Kelso and Most, 164; Mark P. Leone, Elizabeth Kryder-Reid, Julie H. Ernstein and Paul A. Shackel, "Power Gardens of Annapolis," *Archaeology* 42 (1989): 35–39, 74–75; Barbara Wells Sarudy, "Gardening Books in Eighteenth-Century Maryland," "Eighteenth-Century Gardens of the Chesapeake," "A Chesapeake Craftsman's Eighteenth Century Gardens," *Journal of Garden History* 9, nos. 3 and 4 (July–September 1989): 103–59; Peter Martin, *The Pleasure Gardens of Virginia: From Jamestown to Jefferson* (Princeton: Princeton University Press, 1991); Ulysses P. Hedrick, *A History of Horticulture in America to 1860* (New York: Oxford University Press, 1950), 107.

223. James Monroe to James Madison, July 25, 1810, *Papers of James Madison, Presidential Series* 2, 437.

224. Cutts, "Life at Montpelier."

225. Martin, *Pleasure Gardens*, 101, 121, 125; Hunt-Jones, *Dolley*, 73; Sarudy, "Gardening Books," 109; Richard L. Bushman, *The Refinement of America: Persons, Houses, Cities* (New York: Alfred A. Knopf, 1992), 127–31.

226. Bernard McMahon, *The American Gardener's Calendar: Adapted to the climate and seasons of the United States, 9th Edition, greatly improved* (reprint 1839, Philadelphia: A. McMahon, 1806), 76; Hunt-Jones, *Dolley*, 73; Martin, *Pleasure Gardens*, 101.

227. Montlezun, "Frenchman Visits Norfolk," 75, 198.

228. Robert E. Shalhope, "Republicanism and Early American Historiography," *William and Mary Quarterly*, 3rd series, 39 (April 1982): 347–48.

229. Drew McCoy, *The Last of the Fathers: James Madison and the Republican Legacy* (New York: Cambridge University Press, 1989), 35, 65, 75.

230. Montlezun, "A Frenchman Visits Norfolk."

231. James Madison to Thomas Jefferson, July 18, 1793, and July 30, 1793, *Papers of James Madison* 15, 45, 49.

232. Ibid., September 16, 1793, *Papers of James Madison* 15, 113.

233. Montlezun, "A Frenchman Visits Norfolk."

234. William Livingston to James Madison, March 13, 1809, *Papers of James Madison, Presidential Series* 1, 38.

235. George Washington Parke Custis to James Madison, May 31, 1810, *Papers of James Madison, Presidential Series* 2: 363–64.

236. James Madison to Robert R. Livingston, December 9, 1809, *Papers of James Madison, Presidential Series* 2, 120.

237. James Madison to Thomas Jefferson, May 25, 1810, *Papers of James Madison, Presidential Series* 2, 353.

238. James Madison to John Armstrong, March 14, 1809, *Papers of James Madison, Presidential Series* 4, 585–86.

239. James Madison to Thomas Jefferson, May 25, 1810, *Papers of James Madison, Presidential Series* 2, 353; William Jarvis to Thomas Jefferson, January 20, 1810; Thomas Jefferson to James Madison, March 25, 1810; *Thomas Jefferson's Farm Book*, ed. Edwin Morris Betts (Charlottesville: The University Press of Virginia for the American Philosophical Society, 1953, 1976), 125, 126, 128.

240. James Madison to Thomas Jefferson, October 19, 1810, *Papers of James Madison, Presidential Series* 2, 586.

241. James Madison to William Jarvis, June 17, 1810, *Papers of James Madison, Presidential Series* 4, 619–20.

242. Richard Forest to James Madison, October 6, 1810; James H. Hooe to James Madison, October 14, 1810, *Papers of James Madison, Presidential Series* 2, 572–73, 583; James Madison to William Madison, January 11, 1811, *Papers of James Madison, Presidential Series* 3, 116.

243. Hay Battaile to James Madison, August 16, 1811, *Papers of James Madison, Presidential Series* 3, 421.

244. Thomas Jefferson to William Caruthers, March 12, 1813, *Thomas Jefferson's Garden Book, 1766–1824*, ed. Edwin Morris Betts (Philadelphia: The American Philosophical Society, 1944), 507.

245. James Madison to Richard Peters, March 15, 1811, *Papers of James Madison, Presidential Series* 3, 222.

246. Richard Peters to James Madison, April 6, 1811, *Papers of James Madison, Presidential Series* 3, 247–48.

247. When Madison wrote to Lear, Lear had been serving as consul general in North Africa since his appointment to that position by President Thomas Jefferson in 1803. Prior to this appointment, Lear briefly served as an American consul in Santo Domingo during General Toussaint-L'Ouverture's rule. Lear also served President George Washington as a private secretary and family tutor; James Madison to Tobias Lear, October 26, 1811, *Papers of James Madison, Presidential Series* 3, 501.

248. James Madison to Tobias Lear, October 26, 1811, *Papers of James Madison, Presidential Series* 3, 501.

249. Richard Peters to James Madison, April 6, 1811, *Papers of James Madison, Presidential Series* 3, 247–48.

250. Tench Coxe to James Madison, April 24, 1812, *Papers of James Madison, Presidential Series* 4, 347.

251. Montlezun, "A Frenchman Visits Norfolk."

252. James Madison to Mordecai Collins, November 8, 1790, *Papers of James Madison* 13, 302–03.

253. James Madison Jr. to James Madison Sr., July 28, 1787, *Papers of James Madison* 10, 118.

254. Paul Jennings, *A Colored Man's Reminiscences of James Madison*, Bladensburg Series, number two (Brooklyn, NY: G.C. Beadle, 1865), 17–18.

255. James Madison to James Monroe, October 29, 1793, *Papers of James Madison* 15, 132.

256. James Madison to Charles P. Howard, September 11, 1805, mss. 2 M 2653 b 13, Virginia Historical Society.

257. Thomas Moore, *The Great Error of American Agriculture Exposed*; Thomas Moore to James Madison, April 4, 1802, *Papers of James Madison, Secretary of State Series* 3, 94.

258. Thomas Moore to James Madison, August 16, 1802, *Papers of James Madison, Secretary of State Series* 3, 474.

259. James Madison to Isaac Briggs, October 8, 1802, *Papers of James Madison, Secretary of State Series* 4, 1.

260. Hamilton, ed., *Writings of James Monroe* 3: 158.

261. Aristotle, *The Politics*, Book VI, chap. iv, trans. T.A. Sinclair (1962; reprint New York: Viking Penguin, Inc., 1987).

262. Marvin Meyers, ed., *The Mind of the Founder* (Hanover, NH: University Press of New England, 1981), 184–85.

263. Thomas Jefferson to James Madison, *Papers of Thomas Jefferson* 12, 442.

264. James Madison, *Advice to my Country*, David B. Mattern, ed. (Charlottesville: University Press of Virginia, 1997), 11–12.

265. A. Hunter Dupree, *Science in the Federal Government: A History of Policies and Activities* (Baltimore: Johns Hopkins University Press, 1986), 16.

266. Thornton, *Cultivating Gentlemen*, 8–10.

267. Joyce E. Chaplin, *An Anxious Pursuit: Agricultural Innovation and Modernity in the Lower South, 1730–1815* (Chapel Hill: The University of North Carolina Press for the Institute of Early American History and Culture, Williamsburg, Virginia, 1993), 140–41.

268. Ketcham, *James Madison*, 621.

269. James Madison, "Address to the Agricultural Society of Albemarle," Charlottesville, May 12, 1818, printed in *American Farmer* 1 1819 (typescript on file at the Madison Papers, Alderman Library, Charlottesville), 17.

270. Ibid., 18, 21, 27.

271. Ibid., 22–23, 28–29.

272. James Madison to James Monroe, October 29, 1793, *Papers of James Madison* 15, 132.

273. Carl J. Richard, *The Founders and the Classics: Greece, Rome, and the American Enlightenment* (Cambridge: Harvard University Press, 1994), 8.

274. Linda Kerber, *Federalists in Dissent: Imagery and Ideology in Jeffersonian America* (Ithaca, NY: Cornell University Press, 1970), 112, 187.

275. Madison, "Address," 18.

276. Margaret W. Rossiter, *The Emergence of Agricultural Science: Justus von Liebig and the Americans 1840–1880* (New Haven: Yale University Press, 1975), 91, 102, 109, 132; Dupree, *Science in the Federal Government*, 7.

277. Avery O. Craven, *Soil Exhaustion as a Factor in the Agricultural History of Virginia and Maryland, 1606–1860*, University of Illinois Studies in the Social Sciences 13, no. 1 (Urbana: 1925; reprint, Gloucester, MA, 1965); Richard B. Davis, *Intellectual Life in Jefferson's Virginia* (Chapel Hill: The University of North Carolina Press, 1964), 150; Charles W. Turner, "Virginia State Agricultural Societies, 1811–1860," *Agricultural History* 38 (1964): 167–77; John T. Schlotterbeck, "Plantation and Farm: Social and Economic Change in Orange and Greene Counties, Virginia, 1716 to 1860" (PhD diss., Johns Hopkins University, 1980), Ann Arbor: University Microfilms International, 1980, 283.

278. No. 10 and No. 57, *The Federalist Papers*, ed. Clinton Rossiter (New York: New American Library, Penguin Putnam, Inc., 1996), 50, 52, 318.

279. Leo Marx, *The American Revolution and the American Landscape* (Washington, D.C.: American Enterprise Institute for Public Policy Research, 1974), 4, 9, 10,11–14, 18–19; Leo Marx, *The Machine in the Garden: Technology and the Pastoral Ideal in America* (New York: Oxford University Press, 1964), 71.

280. Orange County Deed Book 32, 222, 256, 375.

281. Brant, *James Madison*, 510.

282. James Madison to Edward Coles, October 3, 1834, Papers of James Madison (acc. no. 2988), Manuscripts Department, University of Virginia Library.

283. Orange County Personal Property Tax List, microfilm reels, Library of Virginia.

284. Martineau, *Retrospect* 1, 192.

285. Elizabeth Langhorne, K. Edward Lay, William D. Rieley, eds., *A Virginia Family and Its Plantation Houses* (Charlottesville: The University Press of Virginia, 1987), 132–41; James Madison to Edward Coles, October 3, 1834, Papers of James Madison (acc. no. 2988), University of Virginia.

286. Peter Force, "Scrapbook about James Madison," mss. 9911, McGreggor Room, M-2275, Slipcase #51, Special Collections, Alderman Library, University of Virginia, 15.

287. Orange County Will Book 8, 217–19.

CHAPTER SEVEN

288. Dolley Payne Madison to Mrs. Richard B. Lee, July 26, 1836, the Papers of Dolley Payne Madison, mss. 18,940, Library of Congress (PDPM-LC).

289. Septima Anne Cary Randolph Meikleham, "Montpelier, Quiet Home Life of Mr. and Mrs. Madison," Randolph-Meikleham Family Papers, Alderman Library, University of Virginia, mss. 4726-a.

290. Dolley Payne Madison to Mrs. Elizabeth Lee, February 19, 1840, PDPM-LC.

291. Anthony Morris to Dolley Payne Madison, May 10, 1837, PDPM-LC.

292. Smith, *Washington Society*, 381

293. U.S. Census, 1830, Orange County, 321; U.S. Census, 1840, Orange County, 629; Orange County Personal Property Tax List, Library of Virginia.

294. Smith, *Washington Society*, 379.

295. Dolley Payne Madison to General B. Peyton, July 13, 1840, PDPM-LC.

296. Dolley Payne Madison to A.H. Palmer, May 12, 1842, PDPM-LC.

297. No Name, 1837, Container 1-2, Reel 1, 357-369, PDPM-LC.

298. Scott, *A History of Orange County*, 116

299. Lucia Beverly Cutts, ed., *Memoirs and Letters of Dolly Madison, Wife of James Madison, President of the United States* (Boston: Houghton, Mifflin & Co., 1886), 189.

300. Dolley Payne Madison to Dr. Sewall, June 17, 1841, DPDM-LC.

301. Dolley Payne Madison to Mrs. Elizabeth Lee, February 19, 1840, PDPM-LC.

302. No Name, 1837, Container 1-2, Reel 1, 367-369, PDPM-LC.

303. U.S. Census, 1840, Orange County, 629.

304. William Smith to John P. Todd, October 11, 1837; Orange County Deed Book 37, 206; Orange County Land Tax Book, Library of Virginia, Richmond.

305. John P. Todd to Philip S. Fry and Starke W. Morris, January 26, 1846; Orange County Deed Book 40, 129–31.

306. Dolley Payne Madison to John Payne Todd, June 16, 1844, July 17, 1844, Papers of the Madison Family, 1768–1866, mss. 2988, Special Collections, Alderman Library, University of Virginia.

307. Cutts, ed., *Memoirs and Letters*, 206.

308. Orange County Deed Book 40, 129–31.

309. Orange County Will Book 12, 18.

310. C.G. Chamberlayne, *Ham Chamberlayne: Virginian, Letters, and Papers of an Artillery Officer in the War for Southern Independence* (Richmond: Deitz Press, 1932), 188.

311. Smith, *Washington Society*, 382–83.

312. Dolley Payne Madison to Eliza Lee, June 28, 1836, Gilder Lehrman Collection, #07525 ANS, PML, NYC.

313. Anthony, *Dolly Madison*, 332–34.

314. Smith, *Washington Society*, 380.

315. Dolley Payne Madison to Richard Cutts, September 28, 1846, Papers of the Madison Family, 1768–1866, mss. 2988, Special Collections, Alderman Library, Univeristy of Virginia.

316. Anthony, *Dolly Madison*, 365, 369.

317. Cutts, ed., *Memoirs and Letters*, 206.

318. Meikleham, " Montpelier."

319. Anthony, *Dolly Madison*, 378–79.

320. Orange County Deed Book 38, 38: 459–61.

321. Dolley Payne Madison and John P. Todd to Henry W. Moncure, December 29, 1842; Orange County Deed Book 39, 124–26.

322. Orange County Personal Property Tax List; Orange County Land Book, Library of Virginia.

323. Henry W. Moncure to Anna Payne, March 7, 1843, PDPM-LC.

324. Henry W. Moncure to Dolley Payne Madison, December 17, 1842, Papers of the Madison Family, 1768–1866, mss. 2988, Special Collections, Alderman Library, University of Virginia.

325. Henry W. Moncure to Anna Payne, May 13, 1843, PDPM-LC.

326. Ibid., March 7, 1843, PDPM-LC.

327. Ibid., May 13, 1843, PDPM-LC.

328. Ibid., February 4, 1843, PDPM-LC.

329. Ibid., June 17, 1843, PDPM-LC.

330. Henry W. Moncure to Anna Payne, June 17, 1843, PDPM-LC.

331. Ibid., March 14, 1843, PDPM-LC.

332. Ibid., June 17, 1843, PDPM-LC.

333. Ibid., May 13, 1843, PDPM-LC.

334. Ibid., June 17, 1843, PDPM-LC.

335. John P. Todd to Dolley Payne Madison, January 4, 1844, DPM-LC.

336. Ibid., April 6, 1844, DPM-LC.

337. Ibid., April 30, 1844, DPM-LC.

338. Dolley Payne Madison and John P. Todd to Henry W. Moncure, August 1, 1844; Orange County Deed Book, 39, 416–21.

339. Anthony, *Dolly Madison*, 373–75.

340. Orange County Deed Book 39, 418.

341. Dolley Payne Madison to John P. Todd, July 15–17, 1844, Papers of the Madison Family, 1768–1866, mss. 2988, Special Collections, Alderman Library, University of Virginia.

342. John P. Todd to Dolley Payne Madison, January 4, 1844, PDPM-LC.

343. Ibid., January 31, 1844, PDPM-LC.

CHAPTER EIGHT

344. Scott, *A History of Orange County*, 206.

345. The Will of Dolley P. Madison, February 1, 1841, Madison Papers, #2988, McGregor Collection of Notable Virginia Families, Series IV, Box 4, wills, Alderman Library, University of Virginia.

346. James H. Causten to unidentified recipient, February 16, 1852, Causten Family Papers, mss. 47, Greensboro Historical Museum Archives.

347. John C. Payne to J.H. Causten Jr., March 12, 1852, Causten Family Papers, mss. 47, Greensboro Historical Museum Archives.

348. Ibid., August 15, 1852, Causten Family Papers, mss. 47, Greensboro Historical Museum Archives.

349. Frederick H. Schmidt, "The Madison Cemetery at Montpelier, A Research Report," January 2000, on file at Montpelier Archives.

350. Scott, *A History of Orange County*, 206.

351. Richard G. Carrott, *The Egyptian Revival: Its Sources, Monuments, and Meaning, 1808–1858* (Berkeley: University of California Press, 1978), 7, 11, 82, 133, 139–40.

352. "Monument to Ex-President Madison," *Richmond Enquirer*, October 20, 1857, vol. LIV, no. 51, microfilm, N-US-Va-8, Alderman Library, University of Virginia.

353. Ibid.

354. Ibid.

355. "The Remains of Mrs. Madison," *Richmond Enquirer*, January 26, 1815, vol. LIV, no. 79, microfilm, N-US-Va-8, Alderman Library, University of Virginia.

356. Schmidt, "The Madison Cemetery at Montpelier, A Research Report."

357. *Frank Leslie's Illustrated Newspaper*, vol. 5, no. 113 (30 January 1858): 140.

358. Schmidt, "Madison Cemetery."

359. Virginius R. Shackelford to Robert B. Tunstall, June 11, 1936, Robert Baylor Tunstall Papers, mss. 2T8365b, Virginia Historical Society.

360. Ibid.

361. Gerald Strine, *Montpelier: The Recollections of Marion duPont Scott*, (New York: Charles Scribner's Sons, 1976), 34.

362. Nora Richter Greer, "A Lively Dialogue Focuses on Montpelier's Future," *FORUM* (Fall 1989): 7, 9, acc. no. 1997.48, Montpelier Archives.

363. Linda Wheeler, "A Living Tribute to Madison," *The Washington Post*, March 17, 2001.

BIBLIOGRAPHY

MANUSCRIPTS

Account book of Colonel James Madison Sr. of Montpellier, Orange County. 1776–98. Alderman Library, University of Virginia, Charlottesville, VA.

Account book of Colonel James Madison Sr. of Montpellier, Orange County. 1798–1817. Alderman Library, University of Virginia, Charlottesville, VA.

"Address Delivered before the Agricultural Society of Albemarle." *American Farmer 1 (1819)*. *Papers of James Madison. Alderman Library, University of Virginia, Charlottesville, VA.*

Andrew Shepherd Account Book. Mss. 661 c 1, Microfilm # M-1117. Rockefeller Library, Colonial Williamsburg Foundation, Williamsburg, VA.

Carter G. Woodson Collection. Library of Congress, Washington, D.C.

Colonel James Madison Sr. Account book, 1744–57. Papers of James Madison. Alderman Library, University of Virginia, Charlottesville, VA.

Cutts, Mary. Life at Montpelier, as Remembered by a Niece of Dolley Madison. Ca. 1855. Montpelier Monograph, 01-F0323. Montpelier Archives, Montpelier Station, VA.

Diaries of Mrs. Anna M.B. Thornton, 1793–1804. Mss. 13.818. Alderman Library, University of Virginia, Charlottesville, VA.

DuPont Family Collection. Montpelier Archives, Montpelier Station, VA.

DuPont Family Scrapbook, O-2, I. Montpelier Archives, Montpelier Station, VA.

Force, Peter. "Scrapbook about James Madison." Mss. 9911, M-2275, Slipcase #51. Special Collections, Alderman Library, University of Virginia, Charlottesville, VA.

Fry-McLemore Collection. Virginia Papers. Mss. 10659-a. Special Collections, Alderman Library, University of Virginia, Charlottesville, VA.

Lee Family Papers. Mss. 1 L 51 c 489, folio 861. Virginia Historical Society, Richmond, VA.

Madison Account Book. 1725–26. Presbyterian Historical Society, Philadelphia, PA.

Madison-Causten-Kunkel Papers, Mss. 47. Greensboro Historical Museum, Greensboro, NC.

Montpelier Estate Records. Montpelier Archives, Montpelier Station, VA.

Papers of Dolley P. Madison. Mss. 18,940. Library of Congress, Washington, D.C.

Papers of John Hartwell Cocke. Mss. 5680, 640, Box 9. Special Collections, Alderman Library, University of Virginia, Charlottesville, VA.

Papers of the Madison Family. 1768–1866. Mss. 2988. Special Collections, Alderman Library, University of Virginia, Charlottesville, VA.

Papers of Merrill D. Peterson. Box 19, R G-21/105.931. Special Collections, Alderman Library, University of Virginia, Charlottesville, VA.

Photograph Collection, Library of Virginia, Richmond, VA.

Randolph-Meikleham Family Papers. Mss. 4726-a. Special Collections, Alderman Library, University of Virginia, Charlottesville, VA.

BIBLIOGRAPHY

Robert Baylor Tunstall Papers. Mss. 2 T 8365 b. Virginia Historical Society, Richmond, VA.

Shane Manuscript Collection. Sh 18 M 265. Presbyterian Historical Society, Philadelphia, PA.

PUBLIC DOCUMENTS

Division of Historic Landmarks. Virginia Department of Historic Resources, Richmond, VA.

Madison County Circuit Court Records. The Library of Virginia, Richmond, VA.

Montpelier Survey of Structures, 1987. Virginia Department of Historic Resources, Richmond, VA.

Orange County Deed Books. The Library of Virginia, Richmond, VA.

Orange County Land Tax Lists. The Library of Virginia, Richmond, VA.

Orange County Minute Books. The Library of Virginia, Richmond, VA.

Orange County Order Books. The Library of Virginia, Richmond, VA.

Orange County Personal Property Tax Lists. The Library of Virginia, Richmond, VA.

Orange County Will Books. The Library of Virginia, Richmond, VA.

Spotsylvania County Order Book. The Library of Virginia, Richmond, VA.

Spotsylvania County Will Book A. The Library of Virginia, Richmond, VA.

United States Census records. Virginia and Maryland.

PERIODICALS

Hemphill, John M., II, ed. "John Wayles Rates his Neighbours." *Virginia Magazine of History and Biography 66 (1958): 305.*

Montlezun, Baron de. "A Frenchman Visits Norfolk, Fredericksburg, and Orange County, 1816." Translated by L.G. Moffatt and J.M. Carrière. *Virginia Magazine of History and Biography* 53 (April/July 1945): 1–41.

Ward, Robert D. "General La Fayette in Virginia, in 1824, An Account of his Triumphant Progress through the State." *A Yorktown Centennial Volume.* Richmond: West, Johnson, & Co., 1881.

NEWSPAPERS

Charlottesville Jeffersonian and *Fredericksburg News,* March 6, 1854. Microfilm, N-US-Va-8. Alderman Library, University of Virginia, Charlottesville, VA.

Frank Leslie's Illustrated Newspaper, January 30, 1858.

Richmond Enquirer, October 20, 1857; January 26, 1858.

PUBLISHED MATERIALS

Chamberlayne, C.G. *Ham Chamberlayne: Virginian, Letters, and Papers of an Artillery Officer in the War for Southern Independence.* Richmond: Deitz Press, 1932.

Cutts, Lucia Beverly, ed. *Memoirs and Letters of Dolly Madison, Wife of James Madison, President of the United States.* Boston: Houghton Mifflin, & Co., 1886.

Gray, Ralph D., ed. "A Tour of Virginia in 1827: Letters of Henry D. Gilpin to his Father." *Virginia Magazine of History and Biography* 76, no. 4 (October 1968): 444–71.

Hamilton, Stanislaus Murray, ed. *The Writings of James Monroe.* 7 vols. New York: AMS Press, 1969.

Jennings, Paul. *A Colored Man's Reminiscences of James Madison.* Bladensburg Series, number two. Brooklyn: G.C. Beadle, 1865.

Le Vasseur, Auguste. *Lafayette in America, in 1824 and 1825; or Journal of his Travels in the United States.* 2 vols. New York: White, Gallagher, & Company, 1829.

Madison, James. *Advice to My Country.* David B. Mattern, ed. Charlottesville: University Press of Virginia, 1997.

Martineau, Harriet. *Retrospect of Western Travel.* New York: Harper & Brothers, 1838. 1942 reprint.

Bibliography

McMahon, Bernard. *The American Gardener's Calendar: Adapted to the climate and seasons of the United States, 9th Edition, greatly improved*. Philadelphia: A. McMahon, 1806. 1839 reprint.

Meyers, Marvin, ed. *The Mind of the Founder*. Hanover, NH: University Press of New England, 1981.

Peden, William, ed. *Thomas Jefferson, Notes on the State of Virginia*. New York: W.W. Norton & Co., for the Institute of Early American History and Culture at Williamsburg, VA, 1982.

Smith, Margaret Bayard. *The First Forty Years of Washington Society*. New York: C. Scribner's Sons, 1906.

Strine, Gerald. *Montpelier: The Recollections of Marion duPont Scott*. New York: Charles Scribner's Sons, 1976.

The Papers of James Madison

Brugger, Robert J., David B. Mattern, Robert A. Rutland, Mary A. Hackett and John C. A. Stagg, eds. *The Papers of James Madison—Secretary of State Series*. 4 vols. Charlottesville: The University Press of Virginia, 1986–98.

Hutchinson, William. T., and William M.E. Rachal, eds. *The Papers of James Madison*. Vol. 1–8. Chicago: The University of Chicago Press, 1962.

Rutland, Robert A., Jeanne Kerr Cross, John C.A. Stagg and Thomas A. Mason, eds. *The Papers of James Madison—Presidential Series*. 4 vols. Charlottesville: The University Press of Virginia, 1984–99.

Rutland, Robert A., John C.A. Stagg and David B. Mattern, eds. *The Papers of James Madison*. Vol. 14–17. Charlottesville: The University Press of Virginia, 1983–91.

Rutland, Robert A., and William M.E. Rachal, eds. *The Papers of James Madison*. Vol. 9–13. Chicago: The University of Chicago Press, 1975–80.

Secondary Sources

Ackerman, James S. *The Villa: Form and Ideology of Country Houses. Bollingen Series 35*. Princeton, NJ: Princeton University Press, 1990.

Ames, Kenneth L. *"Designed in France: Notes on the Transmission of French Style to America." Winterthur Portfolio* 12 (1977): 103–14.

Ammon, Harry. *James Monroe: The Quest for National Identity. Charlottesville: The University Press of Virginia, 1990.*

Anthony, Katharine. *Dolly Madison: Her Life and Times*. Garden City, NJ: Doubleday & Co., Inc., 1949.

Berlin, Ira. *Many Thousand Gone: The First Two Centuries of Slavery in North America*. Cambridge: The Belknap Press of Harvard University Press, 1988.

Berlin, Ira, and Philip D. Morgan, eds. *Cultivation and Culture: Labor and the Shaping of Slave Life in the Americas*. Charlottesville: The University Press of Virginia, 1993.

Berlin, Ira, and Ronald Hoffman, eds. *Slavery and Freedom in the Age of the American Revolution*. Charlottesville: The University Press of Virginia for the United States Capitol Historical Society, 1983.

Betts, Edwin Morris, ed. *Thomas Jefferson's Farm Book, with Commentary and Relevant Extracts from his other Writings*. Charlottesville: The University Press of Virginia for the American Philosophical Society, 1953 and 1974.

———. *Thomas Jefferson's Garden Book, 1766–1824 with relevant Extracts from his other Writings*. Philadelphia: The American Philosophical Society, 1944.

Brant, Irving. *James Madison*. 6 vols. New York: The Bobbs-Merrill Company, 1941–61.

Breen, T.H. *Tobacco Culture: The Mentality of the Great Tidewater Planters on the Eve of Revolution*. Princeton, NJ: Princeton University Press, 1985.

Bushman, Richard L. *The Refinement of America: Persons, Houses, Cities*. New York: Alfred A. Knopf, 1992.

Bibliography

Carr, Lois Green, Philip D. Morgan and Jean B. Russo, eds. *Colonial Chesapeake Society*. Chapel Hill: The University of North Carolina Press for the Institute of Early American History and Culture, 1988.

Carrot, Richard G. *The Egyptian Revival: Its Sources, Monuments, and Meaning, 1808–1858*. Berkeley: University of California Press, 1978.

Carson, Cary, Ronald Hoffman and Peter J. Albert, eds. *Of Consuming Interests: The Style of Life in the Eighteenth Century*. Charlottesville: The University Press of Virginia for the United States Capitol Historical Society, 1994.

Chaplin, Joyce E. *An Anxious Pursuit: Agricultural Innovation and Modernity in the Lower South, 1730–1815*. Chapel Hill: The University of North Carolina Press for the Institute of Early American History and Culture, Williamsburg, VA, 1993.

Chappell, Edward. "Looking at Buildings." *Fresh Advices: A Research Supplement* (1984): i–vi.

———. "Slave Housing." *Fresh Advices: A Research Supplement* (1982): i–iv.

———. "Williamsburg Architecture as Social Space." *Fresh Advices: A Research Supplement* (1981): i–iv.

Chappell, Edward, Willie Graham, Carl R. Lounsbury and Mark R. Wenger. "Architectural Analysis and Recommendations for Montpelier, Orange County, Virginia." Colonial Williamsburg Foundation for the National Trust for Historic Preservation, June 1997.

Craven, Avery O. *Soil Exhaustion as a Factor in the Agricultural History of Virginia and Maryland, 1606–1860*. University of Illinois Studies in the Social Sciences, vol. 13, no. 1. Urbana: 1925; reprint, Gloucester, MA, 1965.

Cronon, William. *Nature's Metropolis: Chicago and the Great West*. New York: W.W. Norton & Co., 1991.

Dalzell, Robert, Jr. "Constructing Independence: Monticello, Mount Vernon and the Men Who Built Them." *Eighteenth-Century Studies* 26 (Summer 1993): 543–80.

Dalzell, Robert F., Jr., and Lee Baldwin Dalzell. *George Washington's Mount Vernon: At Home in Revolutionary America*. New York: Oxford University Press, 1998.

Davis, Richard B. *Intellectual Life in Jefferson's Virginia*. Chapel Hill: The University of North Carolina Press, 1964.

Dupree, A. Hunter. *Science in the Federal Government: A History of Policies and Activities*. Baltimore: The Johns Hopkins University Press, 1986.

Earle, Carville, and Ronald Hoffman. "Urban Development in the Eighteenth-Century South." *Perspectives in American History* X, ed. by Donald Fleming and Bernard Bailyn (1976): 7–78.

Egerton, Douglas R. *Gabriel's Rebellion: The Virginia Slave Conspiracies of 1800 and 1802*. Chapel Hill: The University of North Carolina Press, 1993.

Gaines, William Harris. *Biographical Register of Members, Virginia State Convention of 1861, First Session*. Richmond: Virginia State Library, 1969.

Gordon, Robert B. *American Iron, 1607–1900*. Baltimore: Johns Hopkins University Press, 1996.

Hamilton, Stanislaus Murray, ed. *The Writings of James Monroe*. New York: MAS Press, 1969.

Hatch, John Davis. "John Vander Lyn's Prints of Niagara Falls." *The Magazine Antiques*. (December 1990): 1252–61.

Heck, Marlene Elizabeth. "Building Status: Pavilioned Dwellings in Virginia." In *Shaping Communities, Perspectives in Vernacular Architecture VI*, edited by Carter L. Hudgins and Elizabeth Collins Cromley. Knoxville: The University of Tennessee Press, 1997.

Hedrick, Ulysses P. *A History of Horticulture in America to 1860*. New York: Oxford University Press, 1950.

Hellman, Susan Holway. "Oak Hill, James Monroe's Loudoun Seat." Master's thesis, University of Virginia, 1997.

Hunt-Jones, Conover. *Dolley and the 'great little Madison.'* Washington, D.C.: American Institute of Architects Foundation, Inc., 1977.

Hutchins, Catherine E., ed. *Everyday Life in the Early Republic*. Winterthur, DE: The Henry Francis duPont Winterthur Museum, 1994.

Innes, Stephen, ed. *Work and Labor in Early America*. Chapel Hill: The University of North Carolina Press for the Institute of Early American History and Culture, 1988.

Isaac, Rhys. *The Transformation of Virginia, 1740–1790*. Chapel Hill: The University of North Carolina Press for the Institute of Early American History and Culture, 1982.

Jackson, John Brinckerhoff. *Discovering the Vernacular Landscape*. New Haven: Yale University Press, 1984.

Jamieson, Ross W. "Material Culture and Social Death: African-American Burial Practices." *Historical Archaeology* 29 (1995): 39–58.

Kelso, William M., and Rachel Most, eds. *Earth Patterns: Essays in Landscape Archaeology*. Charlottesville: The University Press of Virginia, 1990.

Kerber, Linda K. *Federalists in Dissent: Imagery and Ideology in Jeffersonian America*. Ithaca, NY: Cornell University Press, 1970.

Ketcham, Ralph. *James Madison: A Biography*. Charlottesville: The University Press of Virginia, 1990.

Kimball, Fiske. *Thomas Jefferson, Architect*. Boston: Riverside Press, 1916.

Kulikoff, Allan. *Tobacco and Slaves: the Development of Southern Cultures in the Chesapeake, 1680–1800*. Chapel Hill: The University of North Carolina Press for the Institute of Early American History and Culture, Williamsburg, VA, 1986.

Lane, Mills. *Architecture of the Old South: Virginia*. Savannah, GA: The Beehive Press, 1987.

Langhorne, Elizabeth, K. Edward Lay and William D. Rieley, eds. *A Virginia Family and Its Plantation Houses*. Charlottesville: The University Press of Virginia, 1987.

Lanier, Gabrielle M., and Bernard L. Herman. *Everyday Architecture of the Mid-Atlantic: Looking at Buildings and Landscapes*. Baltimore: The Johns Hopkins University Press, 1997.

Leone, Mark P., Elizabeth Kryder-Reid, Julie H. Ernstein and Paul Shackel. "Power Gardens of Annapolis." *Archaeology* 42, no. 2 (1989): 35–39, 74–75.

Leone, Mark P., and Parker B. Potter Jr. *The Recovery of Meaning: Historical Archaeology in the Eastern United States*. Washington, D.C.: The Smithsonian Institution Press, 1988.

Lewis, Kenneth E. *The American Frontier: An Archaeological Study of Settlement Pattern and Process*. Orlando, FL: Academic Press, 1984.

Lewis, Lynne G. "Archaeological Survey and the History of Orange County: Another View from Montpelier." *Quarterly Bulletin*, Archaeological Society of Virginia 44 (1988): 149–59.

Lewis, Peirce. "Learning from Looking: Geographic and Other Writing about the American Cultural Landscape." *American Quarterly* 35 (1983): 242–61.

Lubar, Steven, and W. David Kingery, eds. *History from Things, Essays on Material Culture*. Washington, D.C.: The Smithsonian Institution Press, 1993.

Madden, T.O., Jr., with Ann L. Miller. *We Were Always Free: The Maddens of Culpeper County, Virginia, A 200-Year Family History*. New York: W.W. Norton & Co., Inc., 1992.

Martin, Peter. *The Pleasure Gardens of Virginia: From Jamestown to Jefferson*. Princeton, NJ: Princeton University Press, 1991.

Marx, Leo. *The American Revolution and the American Landscape*. Washington, D.C.: American Enterprise Institute for Public Policy Research, 1974.

———. *The Machine in the Garden: Technology and the Pastoral Ideal in America*. New York: Oxford University Press, 1964.

McColley, Robert. *Slavery and Jeffersonian Virginia*. 2nd. ed. Urbana: University of Illinois Press, 1973.

McCoy, Drew R. *The Elusive Republic: Political Economy in Jeffersonian America*. Chapel Hill: The University of North Carolina Press for the Institute of Early American History and Culture, 1980.

———. *The Last of the Fathers: James Madison and the Republican Legacy*. New York: Cambridge University Press, 1989.

McLaughlin, Jack. *Jefferson and Monticello: The Biography of a Builder*. New York: Henry Holt and Company, 1990.

Miller, Ann. *Antebellum Orange: The Pre–Civil War Homes, Public Buildings, and Historic Sites of Orange County, Virginia*. Orange County Historical Society, Inc., 1988.

Moorman, John Jennings. *Mineral Springs of North America*. Philadelphia: J.B. Lippincott & Co., 1873.

Nugent, Nell Marion. *Cavaliers and Pioneers: Abstracts of Virginia Patents and Grants*. Vol. 3. Richmond: Virginia State Library, 1979.

Perdue, Charles L., Jr., Thomas E. Barden and Robert K. Phillips, eds. *Weevils in the Wheat: Interviews with Virginia Ex-Slaves*. Charlottesville: The University Press of Virginia, 1992.

Peterson, Merrill, ed. *The Portable Thomas Jefferson*. New York: Viking, 1975.

Richard, Carl J. *The Founders and the Classics: Greece, Rome, and the American Enlightenment*. Cambridge: Harvard University Press, 1994.

Rodgers, Daniel T. "Republicanism: The Career of a Concept." *The Journal of American History* 79 (June 1992): 11–38.

Rossiter, Clinton, ed. *The Federalist Papers*. New York: Mentor, The New American Library, Penguin Putnam, Inc., 1996.

Rossiter, Margaret R. *The Emergence of Agricultural Science: Justus von Liebig and the Americans, 1840–1880*. New Haven: Yale University Press, 1975.

Schlotterbeck, John T. "Plantation and Farm: Social and Economic Change in Orange and Greene Counties, Virginia, 1716 to 1860." PhD diss., The Johns Hopkins University, 1980. Ann Arbor: University Microfilms International, 1980.

Schmidt, Frederick H. "The Madison Cemetery at Montpelier, A Research Report." January 2000, unpublished manuscript, Montpelier Archives.

Scott, W.W. *A History of Orange County*. Richmond: Everett Waddey Co., 1907.

Shalhope, Robert E. "Toward a Republican Synthesis: The Emergence of an Understanding of Republicanism in American Historiography." *William and Mary Quarterly* 3d Ser. 29 (January 1972): 49–80.

Sinclair, T.A., trans. *Aristotle, The Politics*. 1962. Reprint. New York: Viking Penguin Books, 1987.

St. George, Robert Blair, ed. *Material Life in America, 1600–1860*. Boston: Northeastern University Press, 1988.

Stetson, Sarah Pattee. "American Garden Books Transplanted and Native, before 1807." *William & Mary Quarterly* 3d ser. 3 (July 1946): 343–69.

Thornton, Tamara Plakins. *Cultivating Gentlemen: The Meaning of Country Life among the Boston Elite, 1785–1860*. New Haven: Yale University Press, 1989.

Tinkcom, Margaret Bailey. "Caviar along the Potomac: Sir Augustus John Foster's 'Notes on the United States,' 1804–1812." *William and Mary Quarterly* 3d Ser. 8 (January 1951): 68–107.

Trachtenberg, Alan. *The Incorporation of America: Culture and Society in the Gilded Age*. New York: Hill and Wang, 1982.

Upton, Dell. *Holy Things and Profane: Anglican Parish Churches in Colonial Virginia*. Cambridge: The MIT Press for the Architectural History Foundation, 1986.

———. "Vernacular Domestic Architecture in Eighteenth-Century Virginia." *Winterthur Portfolio* 17 (1982): 95–119.

Walsh, Lorena S. *From Calabar to Carter's Grove: The History of a Virginia Slave Community.* Charlottesville: The University Press of Virginia, 1997.

Wayland, John W. *The Pathfinder of the Seas: The Life of Matthew Fontaine Maury.* Richmond: Garrett and Massie, Inc., 1930.

Wells, Camille. "The Multi-storied House: Twentieth Century Encounters with the Domestic Architecture of Colonial Virginia." *Virginia Magazine of History and Biography* 106 (Fall 1998): 353–418.

———. "The Planter's Prospect: Houses, Outbuildings, and Rural Landscapes in Eighteenth-Century Virginia." *Winterthur Portfolio* 28 (1993): 1–31.

Wenger, Mark R. "The Central Passage in Virginia: Evolution of an Eighteenth-Century Living Place." In *Perspectives in Vernacular Architecture II,* edited by Camille Wells. Columbia: University of Missouri Press, 1986. 137–49.

———."The Dining Room in Early Virginia." In *Perspectives in Vernacular Architecture III,* edited by Thomas Carter and Bernard L. Herman, 149–59. Columbia: The University of Missouri Press, 1989.

———. "Thomas Jefferson and the Vernacular Tradition." Unpublished manuscript presented at Thomas Jefferson, Architect, University of Virginia, Department of Architectural History symposium, Charlottesville, VA, November 1993.

Williams, Frances Leigh. *Matthew Fontaine Maury, Scientist of the Sea.* New Brunswick, NJ: Rutgers University Press, 1963.

Wills, Garry. "Jefferson's Other Buildings." *The Atlantic* (January 1993): 80–88.

Wolschke-Bulman, Joachim, ed. *Places of Commemoration: Search for Identity and Landscape Design.* Washington, D.C.: Dumbarton Oaks Colloquium on the History of Landscape Architecture 19, Dumbarton Oaks Research Library and Collection, 2001.

Yamin, Rebecca, and Karen Bescherer Metheny, eds. *Landscape Archaeology: Reading and Interpreting the American Historical Landscape.* Knoxville: The University of Tennessee Press, 1996.

Yentsch, Anne Elizabeth. *A Chesapeake Family and their Slaves: A Study in Historical Archaeology.* Cambridge, Great Britain: Cambridge University Press, 1994.

ABOUT THE AUTHOR

Matthew G. Hyland holds a master's degree in American Studies from the University of Wyoming and a doctorate in American Studies from the College of William and Mary. He has worked as an architectural historian and a historical archaeologist on a variety of historic preservation projects in the mid-Atlantic region of the United States.

His major areas of research focus on colonial and early national period architecture and landscapes.

Photo by Cade Martin.